THE PORT OF SOUTHAMPTON

Ian Collard

AMBERLEY

First published 2019

Amberley Publishing
The Hill, Stroud, Gloucestershire, GL5 4EP
www.amberley-books.com

Copyright © Ian Collard, 2019

The right of Ian Collard to be identified as the
Author of this work has been asserted in accordance with
the Copyrights, Designs and Patents Act 1988.

ISBN 978 1 4456 8641 7 (print)
ISBN 978 1 4456 8642 4 (ebook)

British Library Cataloguing in Publication Data.
A catalogue record for this book is available from the
British Library.

Origination by Amberley Publishing.
Printed in Great Britain.

Introduction

Southampton has been described as one of Britain's busiest and most successful deep-water ports, with facilities to handle virtually every type of cargo. Its natural deep-water harbour and unique double tide allow unrestricted access for large vessels to berth. The first dock was inaugurated in 1843 and the port has been owned and operated by Associated British Ports since 1982. The average tidal range is approximately 5 feet (1.5 metres), with seventeen hours of rising water caused by the double tides. The principal berths include the Old Dock at the junction of the River Test and Inchen, which consists of berths 20–49, the New Dock, known as the Western Dock, which consists of berths 101–110 and the Container Terminal, which consists of berths 200–207.

It was known as the ancient seaport of Hampton, where the Saxons, under Cedric and Cynric, landed in the year AD 495, establishing a primitive settlement from which emanated the Kingdom of Wessex in the Realm of England. Excavations in connection with the building of the deep-water docks, and especially those for the Empress Dock, provided evidence that the present Southampton Water was once a valley that formed a common outlet for the rivers Itchen and Test. Geological changes took place, resulting in the formation of Southampton Water as we know it today. Stone tools, weapons and the remains of a forest were discovered during the excavations, which led to the conclusion that the valley was inhabited by Ibernian tribes during the Neolithic Age. Most of the relics are on show at the Tudor House Museum at Southampton and these items date back to around 1400 BC, when the Neolithic period came to an end and the Bronze Age was introduced by the Celts, who drove the Ibernians further inland. Evidence of the Celtic occupation can be seen in the tumuli or round mounds on the heath between Beaulieu and Hythe.

It is claimed that the Celts traded with the French across the Channel and that they were the first to use Southampton Water as a port. The Celts were followed by the ancient Greeks and Phoenicians who were searching for tin. The Romans launched a campaign to conquer Britain in AD 43 and it is thought that Emperor Claudius and his legions landed near the River Antona, as Southampton Water was called. Following the Norman Conquest foreign businessmen recognised the advantages of Hampton for developing trade with England. In the year 1150, the wine trade was established at the port and the older part of the town still has many wine cellars built in this period. This was followed by the wool trade, which was established at the port in 1250, with the office of 'Peysage', or wool weigher, created as an important post normally held by a nobleman, the Earl of Warwick being one of the first to be given the post.

Around 1325 the Venetian trade commenced, with commerce to the East and business with Genoa and Spain. Southampton became the centre for all trade with the Levant and merchants from Genoa settled in the town. One of these became involved in a project to improve the facilities at the port but he lost his life, which was claimed on a plot by his rival London merchants. However, the other Genoese merchants obtained the concession of landing all their goods at Southampton from Henry IV in 1402. This agreement brought to an end the previous policy of Edward III, which was to land all of this trade at Calais.

Southampton became the third port of the United Kingdom in 1450, behind London and Bristol. It was claimed that one eighth of the whole wine trade of the country passed through Southampton, and in addition to wine wax, honey, cotton, flax, sugar and fruits passed through the port from Genoa. Following the prohibition of wool exports, the trade in this product showed a decline. In 1544 Queen Mary met Philip of Spain at Southampton and was so pleased with her reception that she granted the town a monopoly to import all sweet wines from the Levant. In the reign of James I in the seventeenth century the port's trade was mainly with France, Spain and the Channel Islands. There was also a considerable amount of cargo being shipped in the coastal trade around the British Isles and in the eighteenth century the fish trade was carried out between Southampton and Newfoundland.

At the beginning of the nineteenth century, dues, known as Petty Customs, were imposed on goods passing through the port by Southampton Corporation. The burgesses were unhappy with this

arrangement and suggested the building of new docks at the port. Southampton Corporation felt that they should be compensated for the loss of dues and it was suggested that they receive one fifth of the harbour dues in lieu of Petty Customs from the date of the opening of the docks. The Town Quay was constructed in 1803, replacing the Watergate Quay. The old West Quay jetty is where the Pilgrim Fathers had left in the *Mayflower* in 1620. It was sold in 1810 and later demolished. John Rennie submitted recommendations to Commissioners for improvements to the port, and John Doswell was employed to supervise the execution of works. George III's Act 43 of 1803 was altered and amended in 1810, allowing powers for the appointment of a commissioner for rates chargeable under the Act. However, the huge cost of building and providing the infrastructure for the new dock provided a problem and the scheme was delayed until 1836, when the Southampton Dock Company was incorporated by an Act of Parliament. The first general meeting of the company, under the chairmanship of Richard Heathfield, was held on 16 August 1836 at the George and Vulture Tavern, George Yard, Lombard Street, London. The Royal Pier was officially opened by the Duchess of Kent and her daughter, Princess Victoria, in 1833. An eastern extension of Watergate Quay was completed in 1835.

It was announced that 216 acres of land adjoining the Town Quay at Southampton had been purchased at a cost of £5,000, subjecting it to being used as docks and 'providing other accommodation for the trade of the port within twenty-one years of the passing of the Act'. The plans provided for the 'building of four wet docks, with vaults, warehouses and sheds, leaving about 19 acres for timber ponds or other purposes'. The meeting agreed that £5,000 was a fair and full price for land which was bounded on the east by the River Itchen, on the south by Southampton Water, on the west by the River Test and on the north by the town of Southampton. The eastern approach to Southampton Water is through Spithead, the channel between the Isle of Wight and the Hampshire shore. The western approach is the Solent, the western arm of the channel that separates the Isle of Wight from the mainland. The estuary of the Test and the Itchen is formed by Southampton Water.

An Act was passed in 1836 incorporating the Southampton Dock Company and it was decided to proceed with the construction of the dock, referred to as the North East Open Dock, now known as the Outer Dock. Unfortunately, it took some time to transfer the title from the Corporation of Southampton and documents including the Charter of Henry II needed to be consulted. In 1838 a further Act of Parliament amended and enlarged powers for maintaining piers etc., and the first stone of the Outer Dock was laid on 12 October that year. The lock gates were opened on 18 June 1842 allowing water to enter, and the dock was used on 30 August that year by two P&O vessels, one of which landed passengers and cargo travelling from Gibraltar to London at the North Western Quay. The dock was opened to general trade on 1 July 1843, when the P&O vessel *Pacha* arrived from Gibraltar with cargo and later sailed with passengers and goods. The fourteen mail steamers of the Royal Mail Steam Packet, trading to the West Indies and South America, also used the dock. Vessels trading between the United Kingdom and France also used the facilities at the Outer Dock. In 1842 the President of the Institution of Civil Engineers stated:

> The large and convenient docks at Southampton will be a useful public improvement, and the estate of the Dock Company appears very favourable for their construction. In combining great security as a harbour, ease of access for ships of large burden in all weather and at all times of the tide, a good roadstead and holding ground, a very gentle run of tide with but little deposit, and an expeditious connection with London by railway, Southampton possesses peculiar advantages.

In 1845 the aggregate amount of tonnage entering the dock was 158,680 and 228,771 the following year, which was an increase of 44.2 per cent. An Act of Parliament allowed increased power to borrow money. Two graving docks were constructed on the south side of the dock; the first was opened on 11 July 1846, and the second the following year. However, the two dry docks proved inadequate and it became clear that a larger facility was required. Dry dock No. 3 was completed in 1854 at a cost of £53,000, and had a floor length of 424 feet.

Work on the Inner Dock commenced in 1846 and the dock was completed five years later. The following year a railway was constructed from the London & South Western Railway terminus station to the Town Quay. The Inner Quay was opened to shipping in 1851 and a new type of buoy was designed by Captain Peacock for Calshot Spit. The increase in the number of ships using the port and requiring ship-repair facilities demonstrated the need for another dry dock and the foundation stone for this was laid in October 1853, with the dock being completed the following year. The new dry dock was 80 feet wide and 477 feet long and was the largest in the port until the opening of the Prince of Wales Graving Dock in 1895. The Union Steamship Company commenced a monthly mail service to South African ports in 1857 with the sailing of the *Dane*, and the Hamburg America Line called at Southampton en route from Germany to New York. Norddeutscher Lloyd vessels commenced calling on the North American service the following year.

A 300-foot-long extension seaward of Town Quay was constructed and a river quay on the west side of the Itchen was opened in 1876, offering an additional 1,756 feet of quay, and a fourth dry dock was opened in 1877 on the eastern bank of the Outer Dock. An Act of Parliament of 1877 created the Southampton Harbour Board, which succeeded the Southampton Harbour Commissioners, which had been in existence since 1803. Further extensions to Town Quay were built and warehouses constructed and in 1867 an Act was passed allowing for the abolition of certain exemptions from local dues on shipping and on goods carried in ships. In 1869 the vessel used for reporting ships' arrivals became redundant and was bought by the Board and converted to a light vessel. The Board undertook maintenance of the buoys in 1878, and an Act was passed in 1882 giving powers to improve channels by dredging and for further construction of works and levying of rates. The first channel improvement scheme to deepen Netley Shoal to 26 feet commenced in 1889.

The construction of the Empress Dock commenced in 1886, and it was opened by Her Majesty Queen Victoria on 26 July 1890 aboard the Royal Yacht *Alberta*, which broke a ceremonial ribbon across the dock entrance. The new dock provided an additional 3,500 feet of quay and was the last extension undertaken by the Southampton Dock Company. The company opened negotiations with the London & South Western Railway in February 1891 in order to raise further capital to meet the expanding requirements of the docks and the first electric wharf cranes in Britain were installed at the Town Quay. On 1 November 1892 the whole of Southampton Docks was acquired by the London & South Western Railway. The first work undertaken was the construction of the Itchen Quays. The Quays were 1,951 feet long and were completed in 1895. The Prince of Wales Graving Dock was built at the same time. It was the largest in the world and was 745 feet long by 91 feet wide. The dock was opened on 3 August 1895 by HRH the Prince of Wales (King Edward VII). Between 1893 and 1896 the main channel above Fawley was dredged to 30 feet and the first lighted marking buoys were installed in port by the Pintscher Patent Lighting Company.

Following completion of the Itchen Quays, work commenced on the South Quay and Test Quays. They were 425 feet and 4,220 feet respectively and were completed in 1902. The International Cold Storage & Ice Company built one of the largest cold storage installations in the country and this was opened in 1901. Work commenced on another larger graving dock, which was 912 feet long and 100 feet wide, and it was opened by the Marquis of Winchester on 21 October 1905, the centenary of the Battle of Trafalgar, and named the Trafalgar Dock. It was the largest dry dock in the world at the time of its opening. However, when the Olympic class ships were ordered in 1908 it was decided to enlarge the dock. The concrete was drilled and cut out in 5-ton blocks capable of handling, and the entrance gates were replaced by a sliding caisson. This took two years to complete, and on 4 April 1913 the American Line's *St Louis* was docked, followed by the *Olympic* the next day. Cunard Line came to Southampton and to accommodate their largest ship, *Berengaria*, a 'V' section was cut at the head of the dock in 1922 for the ship's bow. Even then the stern hung over the caisson and there was only a 10-inch gap between shipside and dockside. White Star Line's North Atlantic service was transferred from Liverpool to Southampton in 1907 and was inaugurated by the *Adriatic*.

The first dredging contract was awarded in 1907 for deepening the approach below Calshot to 32 feet. The dredging took place in 1910–13 and involved the entire approach from Calshot to Ocean Dock and widening swinging ground off Ocean Dock to 35 feet. A new dock was completed in 1911, which was first called the White Star Dock as it was intended for the White Star liners since the company had decided to make Southampton its terminal port. Five large passenger liners could berth at the dock at the same time and its name was changed to the Ocean Dock in 1922. On one occasion *Mauretania* (30,696 toms), *Berengaria* (52,101 tons), *Homeric* (34,351 tons), *Majestic* (56,599 tons) and *Olympic* (46,439 tons) were in the Ocean Dock together.

During the First World War Southampton was Britain's No. 1 port of embarkation, and during that period the record of traffic dealt with was as follows:

Personnel	7,689,510
Horses and Mules	856,492
Guns and Limbers	14,770
Vehicles	177,953
MFO Parcels and Mailbags	7,436,916
Stores, Ammunition (Tons)	3,381,274

An Act for dissolving and reincorporating the Southampton Harbour Board was passed in 1913 and following the end of hostilities the *Imperator* was renamed *Berengaria*, while *Vaterland* became *Leviathan* under the flag of the United States of America. *Bismark* was renamed the *Majestic* as a member of the White Star Line fleet. All of these vessels were regular visitors to the Port of Southampton.

The channel of the estuary approaching the docks was deepened by dredging, making it 600 feet wide and 35 feet deep. When the American liners first came to Southampton in 1893 they had to enter the port at high water, but following the dredging work they had a minimum depth of 30 feet. Cunard Line's North Atlantic express service from Southampton was inaugurated by *Aquitania* on 14 June 1919, followed by Canadian Pacific basing their Canadian service at the port the following year. The Southern Railway commissioned a floating dock, which was placed into position on 21 April 1924 and opened by HRH the Prince of Wales on 27 June that year. New offices were built for the Board in 1925, and a Signal Station was established at Calshot two years later. Between 1927 and 1929 the main channel and approach off West Brambles and the channel off Calshot were widened to 1,000 feet.

The construction of the Extension Quay was one of the greatest engineering feats undertaken in the British Isles. Work commenced on 3 January 1927 to reclaim the land between the Royal Pier and Millbrook Point. A large area had to be dredged and reclaimed before the concrete quay could be added. About 20 million tons of silt and soil had to be moved and a channel 2 miles long and 600 feet wide was dredged to a depth of 35 feet. Below the clay the dredgers brought up trunks of trees that once formed part of an oak forest. Deer bones and the teeth of wild boar were also found. Monoliths, concrete boxes about 45 feet square, were sunk to provide the foundation for the long quay. Every monolith had a steel cutting edge as its base was laid in sections, a standard monolith weighing about 5,000 tons. The first ship to use the New Docks quays was Cunard Line's *Mauretania*, which docked at 101 Berth on 19 October 1932.

The King George V Dock is 1,200 feet long and 135 feet wide and is situated at the western end of the Extension Quay. It was completed in 1933 and was designed to take vessels of 100,000 tons. The site of the dock was formally tidal mud-land, part of the bay of 400 acres reclaimed to form the new docks estate. Altogether 1,258,000 cubic yards of material were evacuated. The concrete floor of the dock is 25 feet thick and 456,000 cubic yards of concrete were used for the floor and walls. The caisson of the dock displaces 4,500 tons of water and when the dock is dry the caisson has to withstand a water pressure of 6,300 tons.

The pumping machinery for the dry dock is housed in a building on the west side of the dock, where there are four 54-inch electrically driven vertical spindle centrifugal pumps for de-watering. Two of these pumps can be used for impounding. The dock contains 260,000 tons (58 million gallons) of water, which

can be emptied in about four hours. The dock was officially opened and named by King George V on 26 July 1933. The Royal Party arrived from Cowes in the yacht *Victoria and Albert*, which severed a red, white and blue ribbon across the entrance, to the accompaniment of cheers from the thousands of spectators lining the sides of the dock. At the ceremony which followed the King said, 'I have much pleasure in declaring the dock open for use and in naming it the King George V Dry Dock, and I pray that, by God's blessing, it may serve to foster and increase the commerce of Southampton.'

The railways on the estate extended to all quays, sheds and warehouses, linking them up to the main line of the Southern Railway, giving direct communication with the railway network of the country. A coal jetty, with electric power cranes and spacious coal barge docks, was provided on the Itchen for the purpose of stowing coal in lighters for bunkering outgoing liners. The coal docks were capable of floating 20,000 tons of coal at any one time. The increase in vessels consuming oil fuel necessitated the provision of special facilities for replenishing bunkers and the major oil companies opened branches and storage depots at the port.

In the late 1920s the main shipping lines operating from Southampton were Cunard, White Star, Compagnie Générale Transatlantique, United States Line and Norddeutscher Lloyd. It is 3,095 nautical miles from Southampton to New York on the northerly route and 3,192 miles by the southern route. Quebec is 2,880 miles and Montreal is 3,019 miles. Cape Town was 5,987 miles by the Union Castle mail route, Sydney is 12,137 miles and Wellington 11,133 miles. Rio de Janeiro and Buenos Aires were served by the Royal Mail Lines and by the Hamburg South America Line. Singapore was served by the P&O Steam Navigation Company and East Asiatic Company, the Rotterdam Lloyd and the Nederland Line and Vancouver by the Royal Mail, Holland America and East Asiatic companies. At one point in 1935, eight of the eleven merchant ships in the world with a tonnage in excess of 40,000 tons gross were making Southampton either a terminal port, or a port of call. These were the *Aquitania, Olympic, Majestic, Berengaria, Empress of Britain, Bremen, Europa* and the *Ile de France*, as well as *Rex* and *Conte di Savoia*, whose route was to the Mediterranean via Gibraltar. The *Normandie* made Southampton her first port of call on her westward passage across the Atlantic.

The Southern Railway vessels provided services from Southampton to the Channel Islands, Havre and St Malo. In 1938 the *Isle of Sark, Isle of Guernsey, Isle of Jersey, Dinard, Lorina, Hanfonia, Normannia* and *Brittany* were employed on the Southern Railway's routes from Southampton. The Southampton–Havre service operated as a route to the French coast and also as a night service to Paris. The crossing took just over seven hours, allowing passengers to enjoy a relaxing overnight sailing. The St Malo route also operated overnight and in the winter months it was an extension of the Channel Islands service. Prior to the Second World War the Southampton fleet used on the night service to France consisted of five turbine steamers, each with a speed of 19.5 knots. Sleeping accommodation consisted of cabins and first and second-class saloons for both ladies and gentlemen. It was a familiar sight to witness the Channel Islands steamer making her way up Southampton Water to berth in the Outer Dock at the traditional time of 4.30 p.m.

During the winter months the number of people going to Jersey via Southampton did not exceed 1,200, but during July the number has grown to over 17,000. The services to Jersey and Guernsey were provided jointly with the Great Western Railway, which operated from Weymouth. During the winter months, the Southern Railway steamers sailed on alternative days with the Great Western Railway. In the summer, the Southern Railway steamers left Southampton every night. It is 120 miles from Southampton to Guernsey, and 30 miles more to Jersey. *The Isle of Sark* was fitted with a maierform bow to reduce water friction and to improve seagoing qualities in bad weather. She was also fitted with Denny-Brown stabilisers to help keep her on an even keel.

When the last of the 'Isle' steamers left Southampton for the breakers, the Channel Islands passenger service was severed in May 1961. The Southern Region of British Railways decided, for reasons of economy, to concentrate the whole of the passenger services at Weymouth. This was a complete reversal of the decision in 1845, when the mails were withdrawn from the Weymouth route and transferred to Southampton. When the Isle of Guernsey made the last passenger sailing to the islands, it was the end of an era in the maritime history of the Port of Southampton.

The trade in South African and Californian fruit was developed in the 1930s. Apart from citrus fruit, such as oranges, huge quantities of deciduous fruit, such as plums, peaches, apricots, mangoes, grapes and pineapples, were unloaded at Southampton. Over 3.5 million packages of this type of fruit were unloaded in 1934. French and Spanish wine has continued to be shipped through Southampton since Norman times. The Red Star Line made Southampton a port of call for the *Westernland* and the *Pennland* on the New York–Antwerp service. The former third-class accommodation on three decks was converted into garages for carrying un-crated motor cars. When the vessel berthed at Southampton the cars were brought up from below by lift to the deck and then moved to another lift, which lowered them down to the quay.

The port has clearly brought prosperity to the town of Southampton. In 1851, when the Inner Dock was opened, 35,305 people were living in Southampton. This figure increased to 64,405 when the Empress Dock was opened in 1890. However, the greatest increase has occurred since 1892, when the docks system passed from the Southampton Dock Company to the London & South Western Railway. The LSWR increased the accommodation and improved the port's facilities, creating jobs and opportunities for local people. In 1892 the population of Southampton was 65,621, and twenty years later it nearly doubled, to 120,512. In 1933 there were 179,000 people living in the town.

In 1939 an Act of Parliament regulated flying boats and seaplanes in the port and the establishment of the Empire Marine Air Base. The first crossing of the North Atlantic took place in July 1938 by the Imperial Airways Short S21 flying boat G-ADHK *Maia* and the Short S20 floatplane G-ADHJ *Mercury*. Later that year the flying boat service was transferred to Berth 108, and a new Imperial Airways terminal was built to provide services to Cairo, Mombasa, Bahrain, Calcutta, Singapore and Sydney. Factories to build the flying boats were established at Hythe and Woolston and in 1939 Imperial Airways merged to form British Overseas Airways Corporation (BOAC). Following the takeover the terminal was moved from Berth 108 to floating facilities off Hythe. The flying boat service was transferred to Poole during the Second World War and the Yacht Club at Salterns Pier was requisitioned as a terminal. Services from Southampton were reinstated on 14 April 1948 from Berth 50, and Aquila Airways was formed the following year. Three SR45 Princess flying boats were built but never went into service. They were moored on the banks of the River Itchen, and later cocooned at RAF Calshot.

The facilities at the port were regularly bombed by enemy aircraft during the Second World War. Twenty-three sheds and warehouses were destroyed or damaged and the Solent Flour Mill was bombed. Sheds 103 and 104 were completely destroyed on the weekend of 30 November to 2 December 1940. Later that month the Red Funnel paddle steamers *Her Majesty* and *Duchess of Cornwall* were sunk moored at Southampton. The tug *Canute* was hit and sank on 28 December, and while under construction at the Thornycroft yard the destroyers *Norseman* and *Oppertune* were badly damaged. Between 1939 and 1945 Southampton Docks dealt with 4.3 million military personnel and 3.9 million tons of stores and equipment. In sixty-nine air raids, 226 bombs fell on the docks, and twenty-three sheds and warehouses were destroyed or seriously damaged.

Following the end of the war it was found that the passenger facilities at the port were proving to be too small and inadequate. On 31 July 1950, Prime Minister Clement Atlee opened the new Ocean Terminal in the Ocean Dock. The building was 1,270 feet long and 120 feet wide and incorporated a railway platform that could accommodate two trains at once. There were two reception halls, with refreshment buffets on the top floor. One was the First Class Hall and the other the Cabin Class Hall. The building incorporated a flower shop, bank, bookstall, writing room and iced water fountain. There was also a customs examination hall, travel agents, railway booking offices and telegraph and cable company facilities. However, with the decline in passenger vessels using the facilities the Ocean Terminal was demolished in 1983. The QEII Passenger Terminal at Berth 38–39 replaced the Ocean Terminal. It was opened by Her Majesty Queen Elizabeth in 1966 and was refurbished in 2003 prior to the introduction of the Cunard cruise and passenger vessel *Queen Mary 2*.

The Esso Marine Terminal was opened in 1951, followed by the construction of British Electricity Authority's Generating Station at Marchwood the following year. The Admiralty Small Craft Base at Hythe (HMS *Diligence*), together with the Control Station on top of Calshot Castle, was opened in 1953. In 1961

Southampton continued to advance both as the premier passenger port and one of the leading cargo ports in the country. Its proportion of passenger traffic with non-European countries in 1960 was 57 per cent (4 per cent higher than the previous year) compared with London's 21 per cent and Liverpool's 15 per cent. The total cargo tonnage shipped and landed in 1960 reached the record figure of 1,345,021 tons, while the gross tonnage of shipping entering the docks was also a record of 24,330,295, which was 1,207,491 tons above the 1959 figure. Experience gained in the use of the Ocean Terminal was put to advantage in the design of subsequent passenger accommodation, notably at Berth 102.

The newest passenger accommodation was at Berth 105–6, where a spacious reception hall was opened in November 1960 for the sailing of the P&O-Orient Line's *Oriana*. The hall, which replaced a smaller lounge provided when the New Docks were opened before the Second World War, was designed primarily for handling the *Oriana* and *Canberra* with their complements of over 2,000 passengers.

Southampton's growing cargo trade required additional facilities. A spacious single-storey shed was completed at Berths 26–27 in the Empress Dock. The port became a leading distribution centre for refrigerated cargos since the opening of the new International Cold Store at No. 108 Berth, New Docks, in 1958. This was built to replace the former cold store, which was destroyed by enemy action in 1940. In the early 1960s Southampton's imports were mainly high-grade cargos requiring speedy handling and prompt despatch. The largest single item was South African fruit. Practically the whole of the deciduous and about half the citrus crop from that country to Britain was shipped to the port. The docks were also the principal landing and transhipment point of South African wool, and in 1959 new accommodation at Berth 25 was completed for the importation of fresh bananas.

In 1961 the Cunard Line carried the largest number of passengers across the Atlantic by sea of any single line. The 1961 total of 177,547 was 30,000 below 1960, which was attributable to the fact that there were twenty-four fewer westbound sailings and twenty-two fewer eastbound sailings than in 1960. The carryings of the *Queen Elizabeth* and *Queen Mary* held up to a total of 103,100 compared with 110,800 in 1960. Their performance demonstrated their continuing appeal to the travelling public. The 1960 Christmas cruise from New York by *Mauretania* was fully booked and *Caronia*'s ninety-day South Pacific Far East cruise proved very popular.

The Standard Telephones & Cables plant at the New Docks was established in 1956 and a second factory was completed adjacent to the original one, giving Southampton the largest potential in the world for submarine cables, covering an area of 18 acres. In 1963 Southampton was fifth among the leading British ports for the value of imports and exports, with an annual value of £320 million. The single-storey cargo transit shed at Berths 26–27, brought into use in 1961 principally for imports of produce from the Mediterranean, provided a valuable addition to cargo facilities. The new accommodation doubled the floor area available for cargo.

The Cunard cruising programme from Southampton during 1963/4 was extended because of increased demand from the public. *Mauretania* undertook three additional cruises from Southampton to the Mediterranean, in addition to the four cruises to the West Indies and the Atlantic Isles. Minimum rates for the three thirteen-day cruises were £58, calling at Tangier, Malta, Messina, Palma and Gibraltar. *Queen Mary* opened the cruise season with two six-day cruises from Southampton to Las Palmas over Christmas and New Year 1964. *Mauretania* sailed on four cruises from Southampton including a thirty-six-day cruise to the West Indies. *Queen Mary* left Southampton on 26 March 1964 on an eight-day Easter cruise. *Carmania* and *Franconia* were employed on a series of West Indies cruises and on completion of their programme returned to the Atlantic service between Rotterdam, Southampton, Havre, Cobh, Quebec and Montreal.

The frequency of sailings by the Ben Line was increased during 1964. Since 1961 they had called regularly once a month, but from July 1963 the frequency was increased to two ships a month. Another new cargo service was by the United States Line, with tri-weekly sailings between Southampton, New York and other east coast ports of the United States.

The hundredth birthday of John I. Thornycroft & Company was officially celebrated on 10 June 1964 by the opening of a new quay, known as Centenary Quay. The ceremony at the quayside was a symbolic

making fast of the first Queen's ships to go alongside. These were three coastal minesweepers, HMS *Nurton*, HMS *Bossington* and HMS *Beachampton*, a class of vessel for the production of which Thornycrofts were selected by the Admiralty to act as parent firm. The three naval ships were dressed overall and the band from the training ship *Mercury* at Hamble played at the ceremony.

A new car-ferry service between Southampton and Le Havre was launched in 1964 by Otto Thoresen. The aim was to provide the fastest and most efficient Continental car ferry service on the four and a half-hour sea passage to Cherbourg, and five and a half hours to Le Havre. The design of the vessels incorporated the latest techniques in passenger comfort and safety. All fixed tables and sofas were effectively insulated from steel decks by vibration-absorbing material, while hangings, curtains and blinds throughout were of fire-resistant material.

Following the introduction of the service the company ordered a third vessel, which was named *Viking III*. The new vessel was built to the same design as *Viking I* and *Viking II*. The decision to build a third after only two months of operation in the Channel was taken because of the high demand for the service and to give the company greater flexibility. A terminal for the new service was provided on the north side of the Outer Dock, which was already used for other Continental services. It included waiting and customs halls, administrative offices, car parks and improved road access. The scheme cost £200,000. Another new cargo service was inaugurated between Southampton to Santander by the Swedish Lloyd Line.

Speaking at the annual meeting of the British & Commonwealth Shipping Company in July 1964, Sir Nicholas Cayzer, the Chairman, announced that from 10 July 1965, the *Windsor Castle* would inaugurate the new, faster mail service to South Africa from Southampton. The voyage time would be reduced from thirteen and a half days to eleven and a half days, and this would allow the service to be operated by seven ships instead of eight. The existing schedule was introduced in August 1936, although at that time only *Stirling Castle* and *Athlone Castle* were able to carry out the faster voyage, and it was not until later that a faster service was in operation. The first mail ships to be built after the war, *Pretoria Castle* and *Edinburgh Castle*, were given a substantial reserve of speed, looking forward to the time when a faster service would be brought into operation. *Pendennis Castle*, *Windsor Castle* and *Transvaal Castle* were all built with the faster schedule in mind. Later, in 1964, Sir John Brocklebank, the Chairman of the Cunard Line, emphatically denied rumours that Cunard intended to change their head office to either London or Southampton.

The stevedoring firm of J. Rose & Company was established in 1898. They were bombed out of their original premises in 1940 and moved to Bowling Green House, overlooking the world's oldest bowling green. W. Wingate & Johnston of Canute Road were established in 1815 and opened their branch office at Southampton soon after the turn of the century. E. H. Mundy & Company were devoted mainly to representing, as port agents, the Hamburg American Line, Hamburg Atlantic Line and North German Lloyd. Overseas Liners & General Agencies opened in June 1961, primarily for the purpose of handling vessels of the Holland America Line, Europe–Canada Line and Oranje Line fleets. F. Smith & Son of Oxford Street operated as nautical and scientific instrument makers, marine opticians and compass adjusters. Harland & Wolff were the principal ship-repairers and engineers on the South Coast. An electrical department was provided, with overhead travelling cranage, and the main marine shop was extended and provided with additional plant. Coast Lines Limited had their Southampton office in the historic old Seaway House, in the centre of the docks area.

In 1965 *Capetown Castle* became the latest Union Castle vessel to carry out cruises for her owners. She completed her last voyage in the South African mail service and following a short refit carried out three voyages to South Africa and a Christmas cruise to Lisbon, Madeira and Tangier. Fares ranged from £63 to £158. *Reina del Mar*, on charter to the Union Castle Line, made three cruises between September and November. These were in addition to the programme of fifteen cruises she completed earlier that year.

P&O–Orient Line's 1967 cruise programme was their biggest ever. Nearly 37,000 berths were available on thirty-two cruises, which was an increase of four cruises and 3,000 berths over the previous programme.

The *Chusan* carried out the largest part of the programme, with fourteen cruises from April to October 1967. *Reina del Mar*, operating for the Union Castle Line, advertised seventeen cruises from Southampton in 1967, ranging from eleven to seventeen days.

A Seaflight H57 hydrofoil arrived in Southampton in January 1969 for use by Red Funnel on their services between Southampton and Cowes. The craft was built by Seaflight S.p.A of Messina and it was claimed that it was the only hydrofoil service in the British Isles, outside the Channel Islands.

Queen Elizabeth 2 sailed from New York in May 1969 on her second transatlantic crossing, with over 1,650 passengers. This was the largest number carried by the ship. Bookings for most transatlantic voyages were heavy, and a high rate of bookings were made, particularly from North America. Most westbound crossings were also heavily booked during 1969. Early in 1969 the Cunard Line appointed Vosper Thornycroft to carry out all the repair work on Cunard passenger ships in Southampton. The contract included work on the *Queen Elizabeth 2* under contract to Upper Clyde Shipbuilders.

Following the decision of P&O Lines in 1969 to operate their passenger fleet, with the exception of the *Cathay* and *Chitral*, exclusively from Southampton, the dock office organisation was streamlined. A section of key staff based in London, and the majority of the staff employed by the company's Southampton agents, Escombe McGrath & Co., were given the responsibility of handling the increased passenger ship business in Southampton. The P&O office at Tilbury was closed, as well as the offices at Plaistow and Greys.

In March 1972 the Elder Dempster Line's passenger vessel *Aureol* had her home port transferred from Liverpool to Southampton. Although at certain times of the year the ship was full, particularly southbound to West Africa, there was a gradual decline in passengers carried. On the northbound voyages from West Africa berth occupancy averaged around 60 per cent for a number of years. However, there was a significant increase in operating costs as the ship carried a large complement, including specialist staff. The Chairman of Elder Dempster Lines said that the withdrawal of the ship in 1974 was a matter of deep regret. It was the end of a service began in the 1860s. *Aureol*'s twenty-nine-day round voyage from Southampton included calls at Las Palmas, Freetown, Monrovia, Tema and Lagos. She carried 250 first-class and 100 cabin-class passengers.

On 19 February 1993, the *Geestbay* sailed from Barry, ending the company's thirty-year association with the port. *Geestcape* took the first sailing from Southampton on 24 February, with the ports of call being the same as from Barry. *Geestport* and *Geesthaven* were also on the service, carrying general cargo westbound and bananas and general cargo eastbound. In 1995 the Geest Line's banana operations were taken over by Fyffes and the Winward Islands Banana Development & Exporting Company. Geest operated as an independent business and chartered four refrigerated cargo vessels. The ports of call for the weekly service from Southampton were St Vincent, St Lucia, Guadeloupe, Martinique, Dominica, Barbados, Grenada, Trinidad, Antigua and St Kitts. The refrigerated cargo ship *Nauru* was the first of the ships to be repainted, and she loaded more than 150 containers in the Caribbean, being one of the largest eastbound container cargoes carried by Geest Line.

The last of Red Funnel Line's Castle class ferries, *Netley Castle,* left Southampton for Croatia on 24 January 1997, when she was acquired by the Croatian line Jadrolinija. She was renamed *Sis* and joined *Cowes Castle*, which became *Nehaj,* and *Norris Castle. Netley Castle* was completed in 1974 for the company's service between Southampton and Cowes. She was purchased by the Croatian Line for the route between Brestova and Porozina. Her former consorts operated on the Zadar–Preko, Zadar–Pula and Herag–Valbiska routes. The high-speed catamaran ferry *Red Jet 3* entered service with Red Funnel Line on their Southampton–Cowes service in July 1998. The vessel joined *Red Jet 1* and *Red Jet 2* and was similar in design to the earlier ships, but it is 2 metres longer and has a different seating arrangement. The *Red Jet 3* replaced the sixty-seven-seat fast ferries *Shearwater 5* and *Shearwater 6* and makes the crossing in twenty-two minutes. The hydrofoils were introduced in in 1969, with *Shearwater 3* in May, 1972 and the *Shearwater 4* in August 1973. *Shearwater 5* entered service in May, 1980, followed by Shearwater 6 in May 1982. *Shearwater 3* and *Shearwater 4* were sold in 1993.

Associated British Ports (ABP) and the vehicle carrier Wallenius Wilhelmsen completed Britain's first port-located multideck car terminal in 2001.The company signed a ten-year agreement with ABP to use the Port of Southampton. The terminal is located at Berth 34 in the Eastern Docks and provides 11.75 acres of storage on five levels for up to 3,120 cars. Four of the levels are covered and the terminal increased Wallenius Wilhelmsen's car handling capacity from 205,000 to 357,000 vehicles a year.

The Princess Royal formally re-commissioned the Vessel Traffic Services Centre at Southampton in 2002. The centre was re-commissioned following a £2.5 million upgrading of its systems, and operates the latest radar systems and technology, with four new radar scanners doubling the radar capacity. The port's harbourmaster has a staff of 120 to manage the waterways and shipping movements. There are 100,000 vessel movements a year which are controlled by watch teams at the centre, providing coverage of the harbour areas at Portsmouth and Southampton.

A third cruise terminal was opened on 14 August 2003. The City Cruise Terminal is adjacent to the Mayflower Park and is used by most of the cruise lines who operate from the port. The new terminal was built at a cost of £1.5 million, and Associated British Ports announced that they had invested over £10 million in facilities for the cruise market at Southampton. This included the major reconstruction and refurbishment of the port's existing cruise terminals: the Mayflower and Queen Elizabeth II. In 2002 nearly half a million passengers passed through the cruise terminals at the port.

Each year the Port of Southampton handles over 100,000 pallets of fresh produce from the Canary Islands. The imports consist of tomatoes, peppers, avocados and cucumbers. The season lasts from October to May and is carried by two refrigerated vessels every week to the purpose-built ABP Canary Islands Terminal in the Western Docks. In 2005 an agreement between Associated British Ports, Southampton Fruit Handling Limited and the Federation of Canary Island Producers was renewed for a further four years.

It was announced in 2008 that a fourth cruise terminal would be constructed at the Port of Southampton after ABP and Carnival UK signed a twenty-year contract. ABP invested £19 million in the new terminal at the Ocean Dock, opposite the site of the old Ocean Terminal. The agreement gave Carnival UK priority use of the port's Queen Elizabeth II and Mayflower Terminals, strengthening the group's relationship with the port. The new Ocean Terminal was opened on 9 May 2009 and was designed to enable the embarkation of 4,000 passengers a day. The facilities included forty state-of-the-art check-in desks, more than 300 short-stay car parking spaces, 8 acres of long stay car parking, thirty coach bays and a dedicated taxi rank and drop-off area for passengers. Associated British Ports announced in 2011 that a new quay wall at Berths 201 and 202 would be constructed. It would be 500 metres in length and would involve an investment of £80 million.

The Port of Southampton was ranked as the most productive port in Europe and the number one performing container terminal in the United Kingdom, according to an independent industry study. These results were based on information from more than 100,000 port calls at 400 ports during 2012. Thee results also placed Southampton at twentieth in the world for productivity, with an average of seventy-one container moves per hour. An extensive dredging operation was undertaken at Southampton, and a new 500-metre container quay was built from an existing facility with the installation of four new cranes.

The former Red Funnel tug/tender *Calshot* took part in a ceremony to mark the 100th anniversary of the sinking of the White Star liner *Titanic*. A flotilla of small vessels re-enacted the departure of the ship from Southampton. The event took place at the Ocean Cruise Terminal, where a wreath and flowers were laid at Berths 46–7 by relatives and guests of the *Titanic*'s passengers and crew. Other vessels involved in the event were SS *Shieldhall* and HMS *Blazer*. *Calshot* was moved to a permanent berth in Trafalgar Dock in April 2011, and the Seacity Museum was opened in 2012. Fred Olsen's *Balmoral* sailed on a *Titanic* memorial cruise on 8 April 2012.

Shipping Operators

Cunard Line

The departure of *Britannia* from Liverpool on 4 July 1840 marked the beginning of a great adventure by Samuel Cunard. The maiden voyage across the Atlantic took fourteen days and eight hours to reach Boston and she was commanded by Captain Woodruff, with Samuel Cunard on board. The three vessels were joined by *Hibernia* in 1843, and *Cambria* replaced *Columbia* the following year. *America*, *Niagara*, *Canada* and *Europe* were introduced in 1848, and *Asia* and *Africa* two years later. Navigation Acts were repealed in 1849 which enabled goods from Europe to be transhipped via Great Britain to America or the Mediterranean.

The express liner service to New York was transferred from Liverpool to Southampton in 1919 and was operated by the *Mauretania*, *Aquitania* and *Berengaria*. One of the later consequences of this move was that the two 'Queens' never actually sailed into their port of registry of Liverpool throughout their lives. It was during the 1920s that the vision of a weekly two-ship express service was discussed by the Cunard Line and in 1930 the keel of hull No. 534 was laid at John Brown's Shipyard on the River Clyde.

Despite the depression in the early 1930s the Germans, French and Italians also ordered new liners. The German *Bremen* took the Blue Riband at 27.8 knots in 1933, the Italian *Rex* recorded 28.9 knots the same year, and the French liner *Normandie* completed a crossing of the Atlantic in just under four days at 30.6 knots in 1937. The construction of hull number 534 was suspended in 1931. In 1933 the Government advanced £3 million to the company. The grant was conditional on the merging of Cunard and the White Star Line.

The merger of the two companies took place in February 1934, under the name of Cunard White Star Limited. The White Star vessels *Majestic*, *Olympic*, *Homeric*, *Britannic*, *Georgic*, *Laurentic*, *Doric*, *Calgaric*, *Albertic* and *Adriatic* were involved in the merger and the Mediterranean services remained under the Cunard Steam Ship Company Limited.

Air travel became increasingly popular in the 1960s with the introduction of the Boeing 707 and the Douglas DC8. It was Pan American who envisaged an aircraft twice the size of these, and Boeing were asked to come up with a design for this mammoth carrier. As the advantages of air travel became apparent to the traveller it was becoming clear to the shipping lines that the airlines were making considerable inroads into their passenger traffic. Although *Mauretania* carried out cruises as well as her transatlantic duties, it was decided that she would be painted 'Caronia' green in 1962 and her cruise programme was increased. *Saxonia* and *Ivernia* were sent back to their builders for a major refit, which included the construction of a lido deck and swimming pool and the installation of air conditioning. They emerged as *Carmania* and *Franconia* and were used as transatlantic liners in the summer and sent cruising during the winter months. *Sylvania* and *Carinthia* were slightly modified and upgraded and this was followed by work carried out on the *Queen Elizabeth* to enable her to undertake cruising duties.

In August 1971 Trafalgar House Investments Limited made a successful bid of £26 million for the Cunard Steam Ship Company. The Main Board of Trafalgar House established a Shipping Division, into which went the Cunard hotel and leisure businesses.

The final nail in the coffin for many British ships employed in cruising was the four-fold increase in fuel cost which took place in 1973–74. Many of the ships were relatively old and soon became uneconomic to operate. The results of the National Seamen's Strike of 1966 had burdened the shipping operators with additional crew wages, there was a decline in demand and other costs were also rising in the early 1970s. *Queen Elizabeth 2*, *Carmania* and *Franconia* were the only passenger vessels owned by Cunard and the returns of only 5 per cent were insufficient to fund replacement vessels.

Seller Kvaerner, an Anglo Norwegian engineering and construction company, took over Trafalgar House in 1996 and the Cunard Line faced an uncertain future. However, two years later the Carnival Corporation negotiated a $500 million deal with minority partners to merge the line with its Seabourn luxury cruise operations. In 1999 they took total control of the company by acquiring the remaining 32 per cent share for 3.2 million Carnival shares and $76.5 million cash, a total value of $205 million.

The Cunard Line announced in 2011 that its passenger vessels would be registered in Bermuda, enabling it to take advantage of the lucrative market for weddings at sea, as these ceremonies are not recognised by British law. Consequently, Hamilton, Bermuda, replaced Southampton on the stern of *Queen Mary 2, Queen Victoria* and *Queen Elizabeth.*

P&O

Willcox & Anderson chartered the Bourne steamers *William Fawcett* and *Royal Tar.* The Spanish Court approved a regular service by the Dublin & London Steam Packet Company with Willcox & Anderson operating the service under the name of the Peninsular Steam Navigation Company. In 1839 Lord William Bentinck, the Governor General of India, was dissatisfied with the arrangements for the mail contract to the subcontinent and this was put out to tender. Willcox & Anderson secured the contract with a bid of £34,200 and *India* was built for the Indian trade. On 23 April 1840 the Board of the Peninsular Steam Navigation changed the name of the company to the Peninsular & Oriental Steam Navigation Company Limited with a share capital of £1 million, and it became known as the P&O Line.

In 1858 the company obtained a new Australian mail contract for £118,000, which specified a passage time to Sydney of fifty-five days. The following year P&O had thoughts of providing links with Japan and the General Administration Manager, Thomas Sutherland, visited the country. It is thought that the intense humidity of the Red Sea voyage led to the word 'posh' being used in relation to the sea journey. The cabins away from the sun were the coolest and outward these were on the port or left and homeward were on the opposite or starboard side. Consequently, regular travellers would book a cabin 'port out, starboard home', which was later abbreviated to POSH. P&O were becoming a household name and their fleet was multiplying to keep pace with its ever increasing service commitments. In 1859 the fleet consisted of fifty-five liners, of which thirty-eight were screw steamers.

At least three quarters of Australia's total overseas trade in the nineteenth century was with England, but in the 1880s foreign buyers began to take a closer interest in the Australian wool auctions. Direct commerce with the European mainland started in 1883 when Messageries Maritimes began their Australian service. Four years later Norddeutscher Lloyd began shipping Australian wool to German, Dutch and Belgium ports. The volume of shipping engaged in the Australian trade was 16 million tons in 1861, and this rose steadily towards the end of the century. The wheat, meat and dairy industries continued to expand in the 1880s, and more ships were needed to carry their produce to Europe.

In 1914 the Australian United Steam Navigation Company was acquired and an amalgamation was made between P&O and the British India Line, in which there was the exchange by each company of £7 million of preference stock, and P&O transferred £638,123 of deferred stock for 1 million British India shares. The joint Board of Directors comprised twelve P&O members and eight from British India. There was a fusion of the business by the interchange of stock. British India's routes were complimentary to P&O and it owned 131 vessels, with a gross tonnage of 598,203 tons.

P&O purchased a minority interest in the Orient Steam Navigation Company and the British India Steam Navigation took control of the Eastern & Australian Mail Steam Ship Company. Frederick Green & Company became associated with Anderson, Anderson & Company in 1877. Anderson & Green became the Orient Steam Navigation Company in 1878. The first ship to fly the company's house flag was the *Garonne*, which sailed for Australia in March of that year.

In the 1960s the following services operated under the name of Orient and Pacific Lines:

Panama Service: Between Europe and the West Coast of America and Canada, via Panama, and from there across the Pacific to New Zealand and Australia or the Far East and vice versa.
South Pacific Service: Connecting Australia, New Zealand, Suva, Honolulu, Canada and the USA.
Japan–Australia Service: Between Australia, Manila, Hong Kong and Yokohama.
Japan–Pacific Service: Connecting Manila, Hong Kong, Yokohama, Honolulu, Canada and the USA.

With the introduction of the passenger jet aircraft, travel by sea was no longer just a matter of transport between two places. It became a way of life and a pleasure, and attracted people who would use the service for a holiday or cruise. Passengers were attracted to the air of unhurried calm with which the ships and crews went about their business. Some would travel on a particular section of the voyage and others would travel around the world on a particular ship.

Princess Cruises were taken over by P&O in 1974 from Stanley B. McDonald, who had founded the line by chartering the Canadian Pacific Alaska cruise ship *Princess Patricia* for Mexican Riviera cruises from Los Angeles. It was announced in 1988 that P&O had acquired Sitmar Cruises and three new vessels under construction. The four ships operating in the Sitmar fleet were renamed *Dawn Princess*, *Fair Princess* and *Sky Princess*, with *Fairstar* retaining her name and operating in the Australian market for P&O-Sitmar Cruises.

Carnival plc is the United Kingdom listed company of the Carnival Group and was formed as a result of the merger between the Carnival Corporation and P&O Princess Cruises in 2003. P&O Princess remained a separate company and was subsequently re-listed as Carnival plc. P&O Princess Cruises owned P&O Cruises, P&O Cruises Australia, Princess Cruises, Ocean Village and AIDA Cruises. Carnival UK also took control of the Cunard Line.

Union Castle Line

The Southampton Steam Shipping Company was formed on 28 September 1853 with Arthur Anderson and Patrick Hadow from the P&O Board as directors. The company was renamed the Union Steam Collier Company on 7 October with plans to build steamers that would make voyages to South Wales to provide coal to P&O, Royal Mail and the General Screw Steamship Company. The five steamers were taken over by the British Government to serve in the Crimean War. They were returned to the company in 1855 when the name of the company was re-registered as the Union Steam Ship Company Limited, later the Union Line. A contract to carry mail to Cape Colony and Natal was awarded to the company in 1857. Donald Currie built up the Castle Packet Company's trade to Calcutta via the Cape, but the opening of the Suez Canal in 1869 severely curtailed this business. The Castle Line then offered a service to South Africa and later became the Castle Mail Packet Company.

In 1873 a mail contract to South Africa was awarded jointly to both the Castle Mail Packet Company and the Union Line. The contract stipulated that the two companies would not amalgamate, but the intense competition led to the Union Line and Castle Shipping Line merging on 8 March 1900. Most of the ships were named with the suffix 'Castle' and their hulls were painted lavender. Every Thursday at 4 p.m. a Union Castle ship would leave Southampton for Cape Town; at the same time, a Union Castle Royal Mail ship would leave Cape Town for Southampton. A 'Round Africa' service was introduced in 1922, with the vessel calling at twenty ports on the nine-week voyage. Alternative sailings sailed out via the Suez Canal and West Africa.

In 1911 the company was acquired by the Royal Mail Line and many of the vessels were converted to troop carriers and hospital ships during the First World War. However, financial problems and the prosecution of Lord Kylsant resulted in the Union Castle Line becoming an independent company

in the early 1930s. A £10 million rebuilding programme was completed in 1939, when the company moved its headquarters to Southampton. The Union Castle Line, King Line, Bullard King and Clan Line merged in 1956, becoming the British & Commonwealth Shipping Company Limited. The South African Marine Corporation merged with the Group in 1973, becoming International Liner Services. *Windsor Castle* made her final sailing to South Africa on 12 August 1977, and *Transvaal Castle* took the last passenger sailing, leaving Southampton on 12 September.

White Star Line

Thomas Ismay, a director of the National Line, purchased the goodwill of a bankrupt company for £1,000 on 18 January 1868. He intended to operate ships on the North Atlantic and acquired headquarters at Albion House, Liverpool. A partnership was arranged with Gustav Wilhelm Wolff and it was agreed that ships for Thomas Ismay's shipping line would be financed, designed and built by Harland & Wolff at Belfast. The Oceanic Steam Navigation was registered on 6 September 1869, with a capital of £40,000, and it became known as the White Star Line. The company planned to operate a weekly service from Liverpool and this required five ships. Negotiations took place with the Mersey Docks & Harbour Board and the company was awarded a berth at West Waterloo Dock.

Adriatic (2) was delivered in 1907 and she was transferred to the Southampton–Cherbourg–New York service. Following a slump in bookings the Liverpool–New York cargo service was suspended from November to March 1909. In 1902 the White Star Line was absorbed into the International Mercantile Marine Company, a large American shipping conglomerate. *Olympic* was commissioned in 1911 and the *Titanic* tragedy occurred on 14 April 1912. The White Star Line lost thirteen ships during the First World War, including *Britannic*, and had to replace vessels on all of their principal routes. On 20 September 1911 the *Olympic* collided with HMS *Hawke* off Cowes Harbour. Emergency repairs were carried out at Southampton on the *Olympic* and she then proceeded to Belfast for more permanent repairs.

The North Atlantic Shipping Bill was passed on 28 March 1934 and Cunard-White Star was formed. At Liverpool the White Star Line moved from its base at Gladstone Dock to Cunard's berth at Huskisson Dock. White Star Line Limited was compulsorily wound up on 8 April 1935, with a deficit of £11,280,864. The assets of the Cunard and White Star Line merged into a new company, Cunard-White Star Limited. Bruce Ismay, the son of the founder, died in 1937 and ten years later the Cunard Steam Ship Company acquired all the shares of Cunard-White Star, and the name of White Star Line disappeared in 1949.

Compagnie Générale Transatlantique (French Line)

The company was established in 1855 by the brothers Emile and Issac Pereire as Compagnie Générale Maritime. The name was changed to Compagnie Générale Transatlantique in 1861, with the *Washington* sailing on its maiden voyage on 15 June 1864. *Paris, Ile de France* and *Normandie* regularly called at Southampton on the North Atlantic service to New York. *France* was introduced in 1962, and in 1977 the company merged with the Compagnie des Messageries Maritimes to form the Compagnie Générale Maritime. In 1966 the company merged to form the CMA CGM.

The Royal Mail Line

The Royal Mail Line was founded in 1839 by James MacQueen and ran tours and mail to various destinations in the Caribbean and South America. The government awarded a mail contract to the company. In 1902, Sir Owen Cosby Philipps (Lord Kylsant) became chairman, embarking on a mission of acquiring interests in multiple companies. For service on the Southampton–Buenos Aires route, *Aragon* was introduced in 1905, *Amazon, Araguaya* and *Avon* in 1906, *Asturias* in 1908, *Arlanza* in 1912, *Andes* and *Alcantara* in 1913 and *Almanzora* in 1915. Royal Mail Lines was formed in 1932

and concentrated on services to the west coast of South America, the West Indies, the Caribbean and the Pacific Coast of North America. The Southampton–Lisbon–Brazil–Uruguay–Argentina route was operated from 1850 to 1980. *Andes* was delivered in 1939 and was converted to full-time cruising from Southampton in 1960.

Shaw, Savill & Albion

The Shaw, Savill & Albion Company was formed in 1882 with the objective of 'operating of steam ships'. In 1928 the White Star Line purchased eighteen Shaw, Savill & Albion vessels and in 1932 the company took over the Aberdeen Line. The following year Furness, Withy & Company acquired control of Shaw, Savill & Albion. *Dominion Monarch* was introduced in 1939 on their service around the world from Southampton. She was joined by the *Southern Cross* in 1955 and replaced by *Northern Star* in 1962. The services from Southampton were withdrawn in 1975.

Holland America Line

The Holland America Line was founded in 1873 and operated a fleet of passenger and cargo vessels from the Netherlands to the east and west coast of America. The company later acquired the stock of the Europa-Canada Line and in 1964 became involved with the Swedish America Line, Axel Johnson and Wallenius Rederiana to form the Atlantic Container Line. In 1988 the company was purchased by the Carnival Cruise Line and the name was retained, continuing the history of the Holland America Line. The company currently operate five different classes of ships: the smaller and older 'S' class vessels; the mid-range 'R' class; the 'Vista' class; the newest and largest 'Signature' class; and the smaller 'Prinsendam' class. *Koningsdam*, delivered on 31 March 2016, is the largest vessel designed and built for the Holland America Line, with a beam of 35 metres, and complies with the new Panamax dimensions, which enable it to cruise through the wider locks in the Panama Canal.

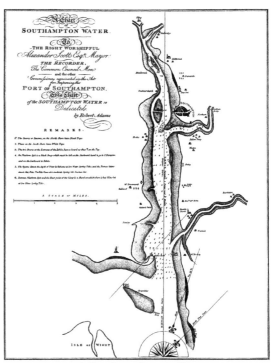

An early chart of Southampton Water.

An Early Chart of Southampton Water.

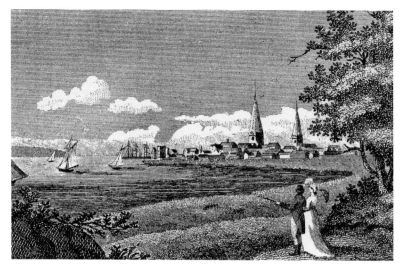

Southampton
around 1803.

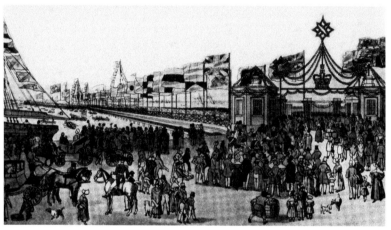

Opening of
the Royal Pier,
Southampton, on
8 July 1833.

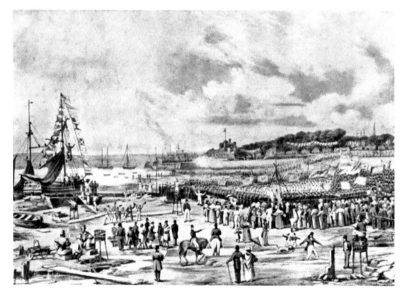

Laying the
foundation stone
of the Outer
Dock on 12
October 1838.

Southampton in 1840.

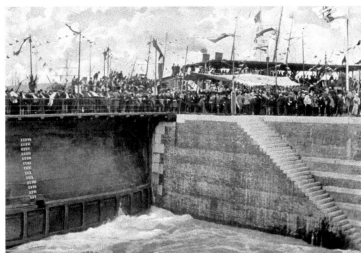

Opening of the Great
Dock at Southampton.

Southampton Docks,
showing the Inner
and Outer Dock,
c. 1852. In the
background are the
spires of St Michael's
and Holy Rood
churches, while on
the left of the Outer
Dock can be seen the
entrances to three
of Southampton's
dry docks, opened
in 1846, 1847 and
1854 respectively.

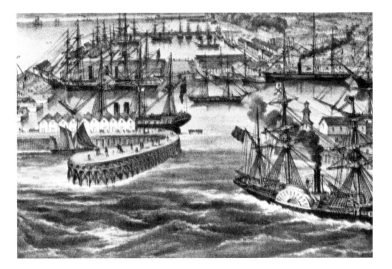

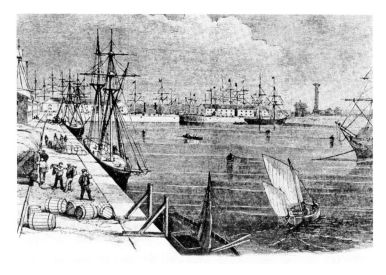

The Inner Dock
in 1852.

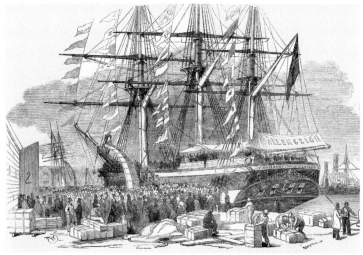

The departure
of the emigrant
ship *Ballengeich*
(1849/477 grt) from
Southampton to
Port Phillip and
Adelaide, Australia,
on 21 August 1852.
She was chartered to
Wyndham Harding
after being fitted
out as a 'family
emigrant ship'.

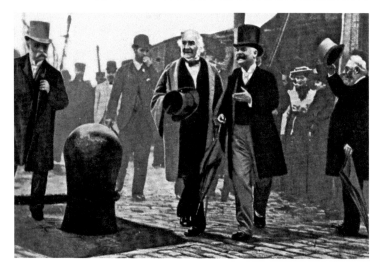

Mr Gladstone arriving
at Southampton
after visiting Queen
Victoria at Osborne
on the occasion of
his becoming Prime
Minister for the
fourth time at the age
of eighty-two years.
16 August 1892.

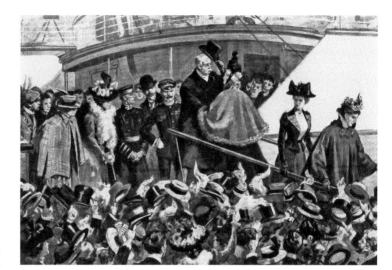

The departure from Southampton Docks of Sir Redvers Buller, VC, for the Boer War.

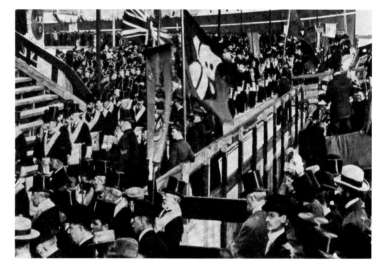

Laying the coping stone at Berth 37 on the 60th anniversary of laying the foundation stone of the First Dock at Southampton.

The Town Quay.

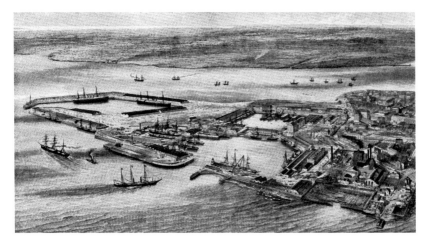

Southampton
Docks
in 1892.

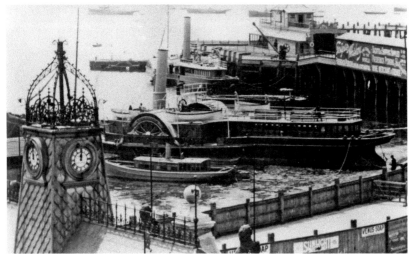

A paddle
steamer at
the Royal
Pier.

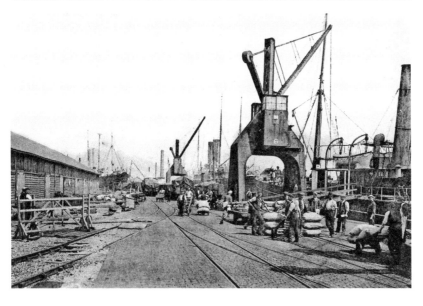

The Ocean
Quay.

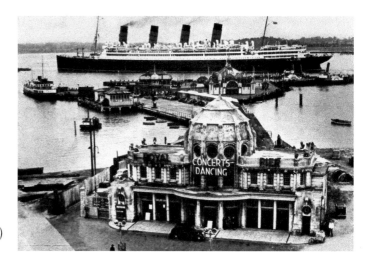

Aquitania (1914/45,647 grt) passing the Royal Pier.

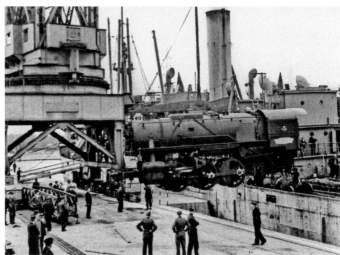

A United States-built locomotive is unloaded at Southampton Docks.

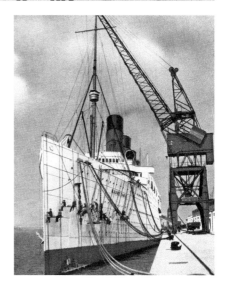

Mauretania (1907/31,938 grt) was built by Swan Hunter & Wigham Richardson, at Wallsend, and sailed on her maiden voyage from Liverpool to New York on 16 November 1907. She served as a troop transport and hospital ship during the First World War, and resumed service on the Liverpool–New York service on 28 June 1919. Her hull was painted white for cruising in 1930, and she was sold in 1935 for scrapping by Metal Industries at Rosyth.

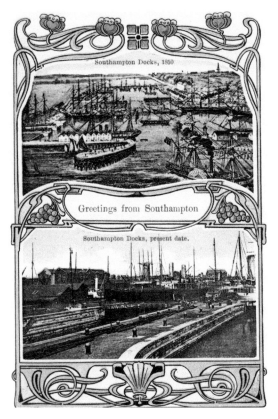

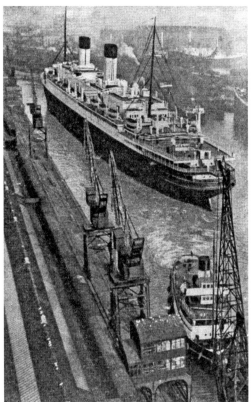

Above left: A greeting card from Southampton.

Above right: *Homeric* (1922/34,351 grt) at the Ocean Dock.

Below: *Majestic* (1922/56,551 grt).

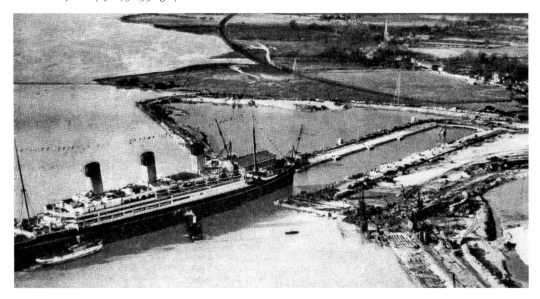

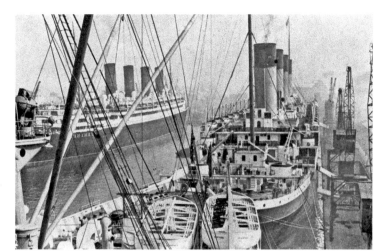

Aquitania (1914/45,647 grt) and *Olympia* (1911/45,324 grt) from *Leviathan* (1914/54,282 grt).

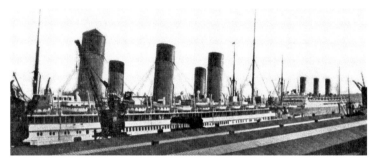

Majestic, Berengaria and *Olympic* at Southampton.

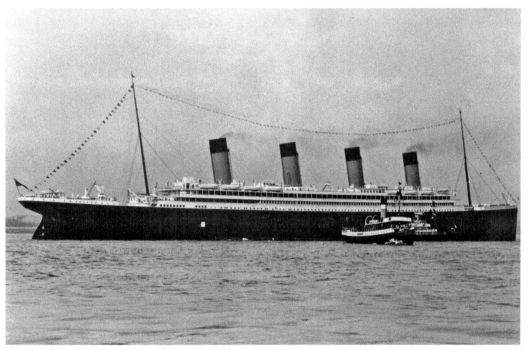

Olympic (1911/45,324 grt).

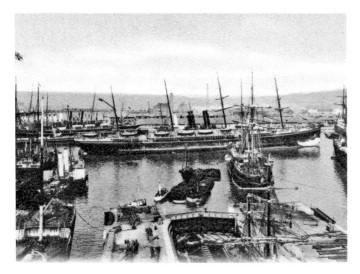

Southampton Docks
around 1900.

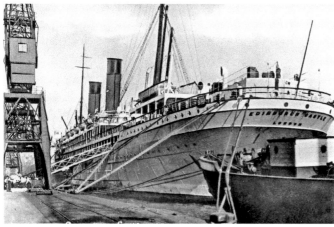

Union Castle Line's
Edinburgh Castle
(1910/13,326grgt) at the
Ocean Quay.

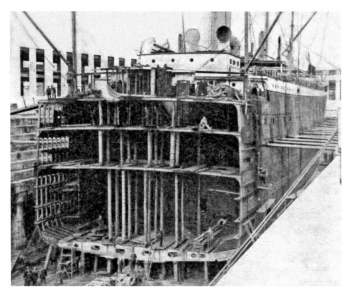

On 17 March 1907, on a
voyage from Australia
to Liverpool, *Suevic* ran
aground near the Lizard
in Cornwall. The cargo
was unloaded and the
aft section of the ship
was later floated free and
sent to Southampton to
enter a dry dock. A new
bow was constructed at
Belfast and this was taken
to Southampton, where
it was fitted to the stern
section. The work was
completed on 14 January
1908, and she was returned
to service with the White
Star Line.

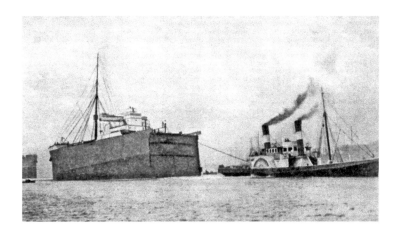

The new bow
leaving Belfast for
Southampton on
19 October 1907.

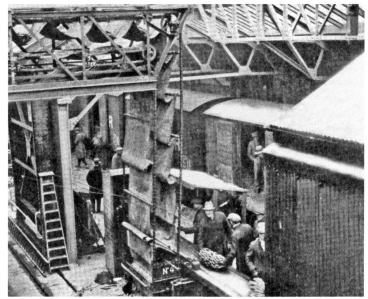

The discharge
of bananas
by conveyor belt.

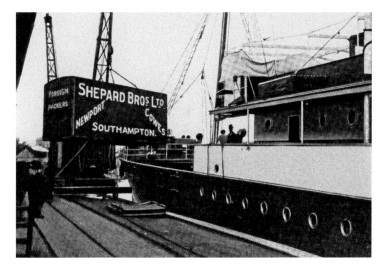

A Shepard Brothers
Limited container
being loaded for
the Southampton–
Newport–Cowes
service.

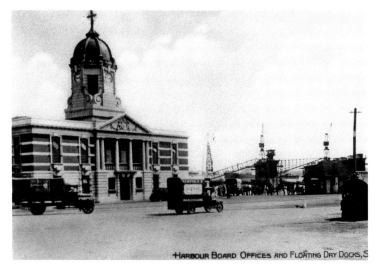

HARBOUR BOARD OFFICES AND FLOATING DRY DOCKS, S

The Harbour Board Offices, with the floating cranes in the background.

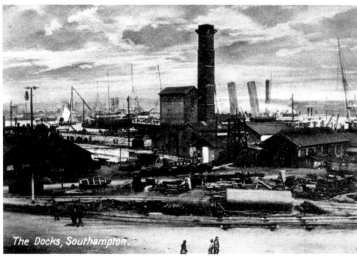

The Docks, Southampton.

The Docks.

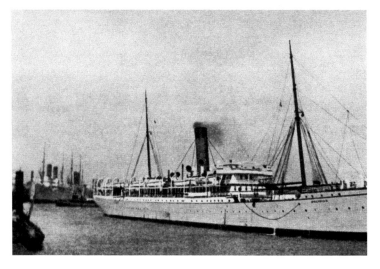

Galatian (1900/6,575 grt) at Southampton. On 15 August 1914 she was boarded by the German raider *Kaiser Wilhelm der Grosse* and later that month she was renamed *Glenart Castle*. On 26 February 1918 she was torpedoed and sunk.

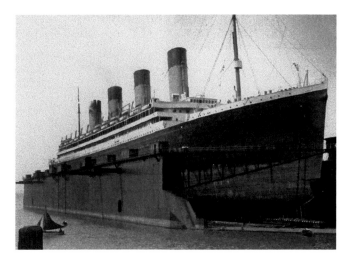

Olympic and *Majestic* in the 'World's Largest Floating Dry Dock'.

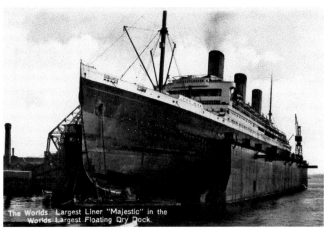

Southern Railway map, *c.* 1926.

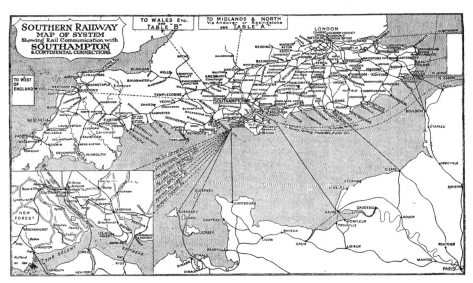

An advertisement for the Southern Railway, c. 1926.

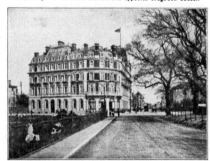
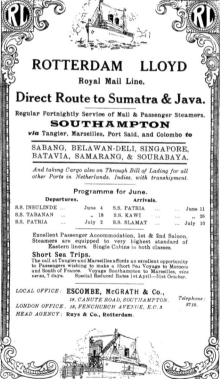
Above left: The South Western Hotel.

Above right: Rotterdam Lloyd advertisement for services to Sumatra and Java from Southampton.

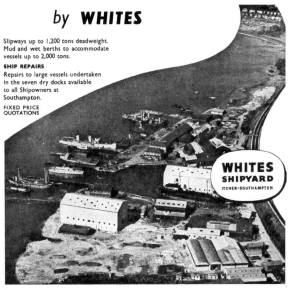
Above left: An advertisement for Whites
Shipyard, Southampton.

Above right: Simons Fruit Brokers, Inner Dock,
Southampton.

Right: Advertisements, *c.* 1926.

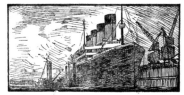

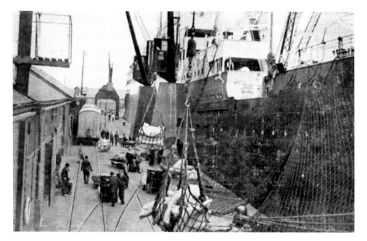

Vessels discharging at
the docks in 1925.

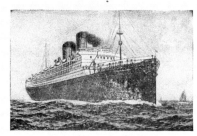

Above left: Mauretania (1907/31,938 grt) in the floating dock.

Above right: Nederland Royal Mail Line advertisement for services from Amsterdam and Southampton in 1926.

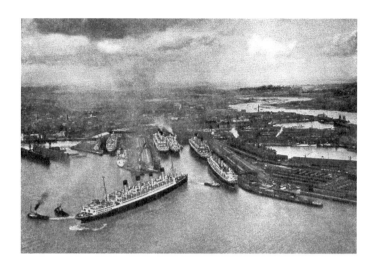

Aquitania, Majestic, Berengaria and *Mauretania.*

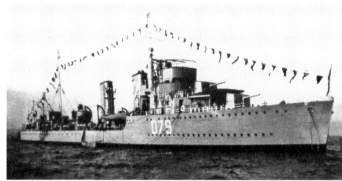

HMCS *Saguenay* was built for the Royal Canadian Navy by John I. Thornycroft & Company at Woolston in 1931.

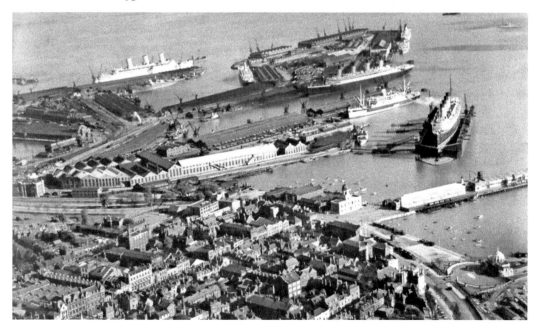

Southampton Docks.

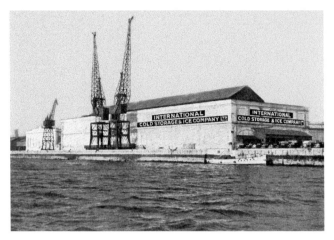

International Cold Storage & Ice Company Limited.

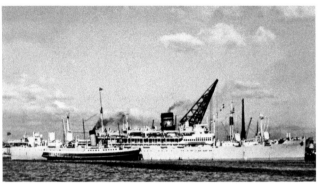

Eastern Prince was launched in 1929 by Napier & Miller Limited at Glasgow for Furness, Withy & Company Limited. She was requisitioned by the Admiralty in November 1940 and converted to a troopship, becoming *Empire Medway*. She was broken up in 1953 as *Faslane*.

Southampton Docks : The Distributing Centre.

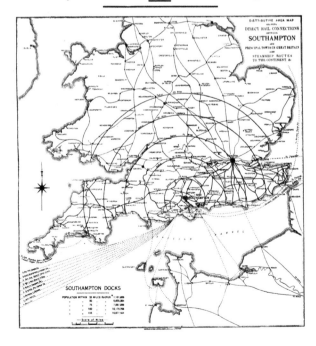

The Distributing Centre at Southampton Docks.

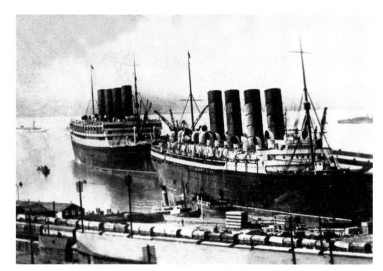

Aquitania (1914/45,647 grt) and *Mauretania* (1907/31,938 grt).

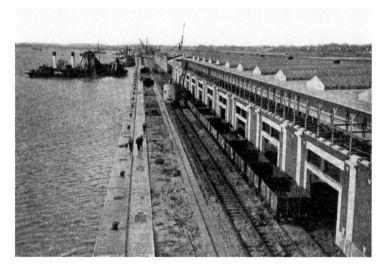

Work is carried out on the quayside at Southampton Docks.

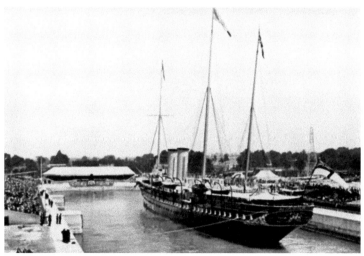

The Royal Yacht *Victoria & Albert*.

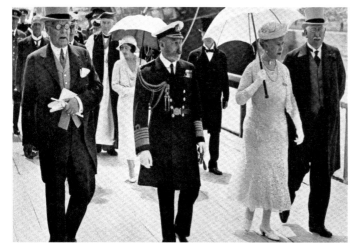

His Majesty King George V, accompanied by Her Majesty Queen Mary, arrived at Southampton in the Royal Yacht *Victoria & Albert* on 26 July 1933 to open the King George V Graving Dock. Walking behind the king and queen were the Duke and Duchess of York, who later became King George VI and Queen Elizabeth.

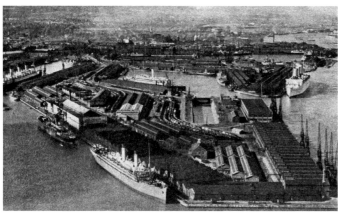

Passenger liners berthed at Southampton Docks.

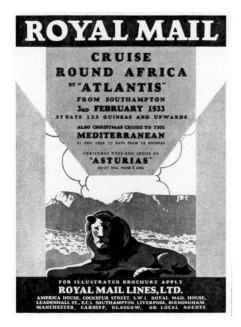

An advertisement for the Royal Mail Line.

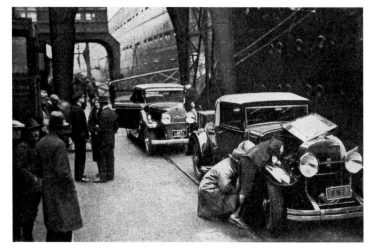

Above: Customs officers examine cars on the quayside at Southampton.

Right: An advertisement for Canadian Pacific, 1933.

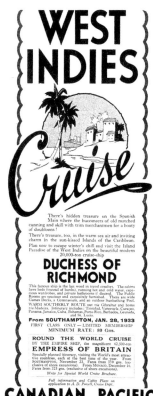

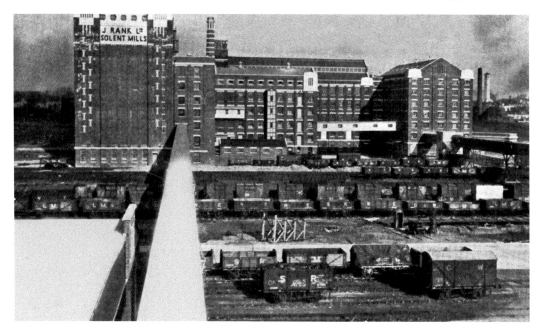

J. Rank Limited, Solent Mills, in 1937.

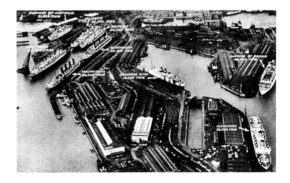

Above: Nine of the world's largest liners at Southampton: *Empress of Australia, Aquitania, Majestic, Homeric, Berengaria, Mauretania, Arandora Star, Empress of Britain* and *Alcantara*.

Left: A 1935 advertisement for J. G. Boyes & Company.

Above: Ocean Restaurant, *c.* 1935.

Left: A 1935 advertisement for Harland & Wolff.

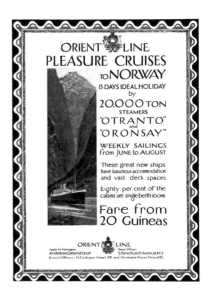

An advertisement for Orient Line Pleasure
Cruises to Norway.

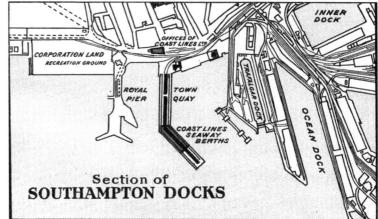

Section of
Southampton
Docks.

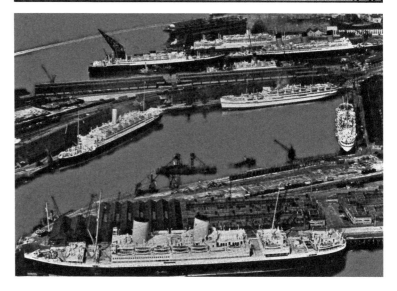

Empress Dock
in 1936.

The dock extension in 1937.

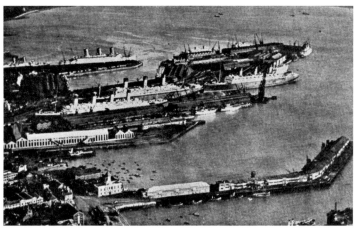

The dock extension in 1936.

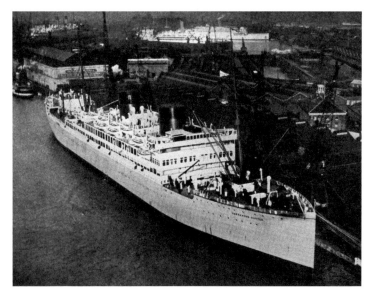

Carnarvon Castle at the Test Quay in 1937.

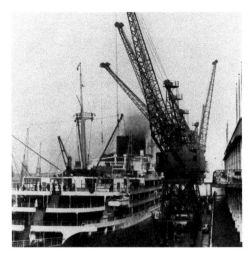

Vessel unloading cargo at the docks.

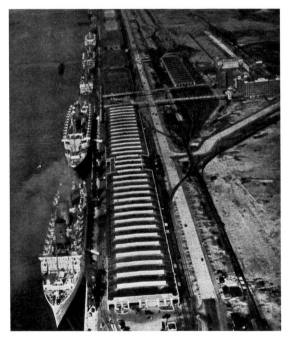

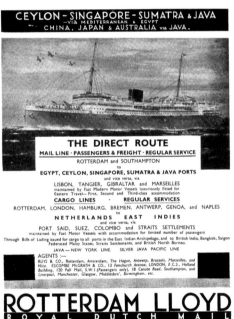

CEYLON - SINGAPORE - SUMATRA & JAVA
—via MEDITERRANEAN & EGYPT
CHINA, JAPAN & AUSTRALIA via JAVA.

THE DIRECT ROUTE
MAIL LINE · PASSENGERS & FREIGHT · REGULAR SERVICE
ROTTERDAM and SOUTHAMPTON
to
EGYPT, CEYLON, SINGAPORE, SUMATRA & JAVA PORTS
and vice versa, via
LISBON, TANGIER, GIBRALTAR and MARSEILLES
maintained by Fast Modern Motor Vessels luxuriously fitted for
Eastern Travel— First, Second and Third-class accommodation
CARGO LINES · REGULAR SERVICES
ROTTERDAM, LONDON, HAMBURG, BREMEN, ANTWERP, GENOA, and NAPLES
to
NETHERLANDS EAST INDIES
and vice versa, via
PORT SAID, SUEZ, COLOMBO and STRAITS SETTLEMENTS
maintained by Fast Motor Vessels with accommodation for limited number of passengers
Through Bills of Lading issued for cargo to all ports in the East Indian Archipelago, and to British India, Bangkok, Saigon
Federated Malay States, Straits Settlements, and British North Borneo.
JAVA — NEW YORK LINE. SILVER JAVA PACIFIC LINE
AGENTS :—
RUYS & CO., Rotterdam, Amsterdam, The Hague, Antwerp, Brussels, Marseilles, and
Nice. ESCOMBE McGRATH & CO., 13 Fenchurch Avenue, LONDON, E.C.3., Holland
Building, 120 Pall Mall, S.W.1 (Passengers only). 18 Canute Road, Southampton, and
Liverpool, Manchester, Glasgow, Middlesbro', Birmingham, etc.

ROTTERDAM LLOYD
R O Y A L D U T C H M A I L

v

Above left: *Berengaria* was laid down as *Europa* and was launched as *Imperator* by the Kaiser in 1912. She was built for the Hamburg-America Line and was the largest ship in the world. When she entered service it was discovered that she was top heavy and she was sent back to her builder, where 10 feet were taken off her funnels and heavy panelling was replaced with lighter material. At the beginning of the First World War she was laid up in the River Elbe. At the end of hostilities she was used to take American troops home to the United States and was later managed by the Cunard Line. When she was purchased by them she was renamed *Berengaria* in 1921, being converted to oil burning and operated with *Mauretania* and *Aquitania*. On 3 March 1938 she was damaged by fire at New York and returned to Southampton without passengers. It was decided that it would be uneconomic to repair her and she was sold to be broken up at Jarrow. However, the demolition was not completed until after the war ended in 1946.

Above right: A 1937 Rotterdam Lloyd advertisement.

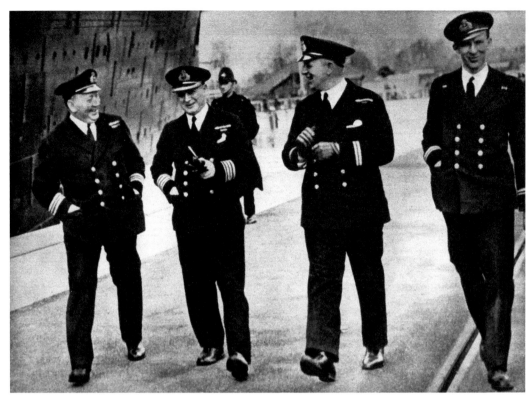

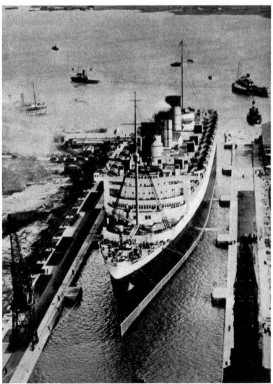

Above: Officers from the *Queen Mary* on the quayside at the King George V Dry Dock.

Left: *Queen Mary* enters the King George V Dry Dock.

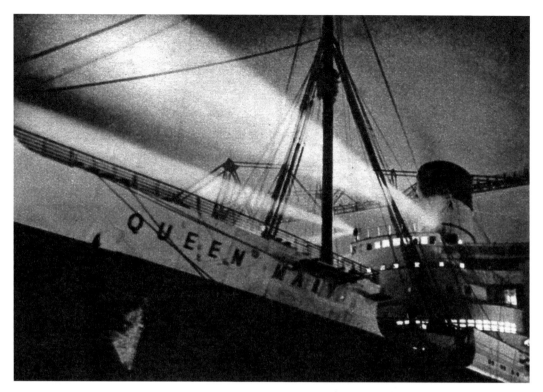

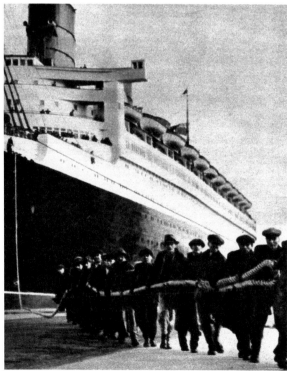

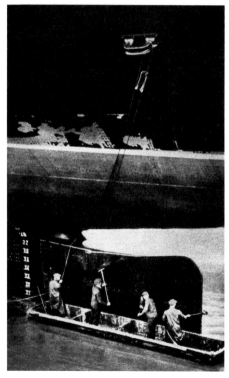

Queen Mary in the King George V Dry Dock.

Above left: A 1937 R. & J. H. Rea Limited advertisement.

Above right: A 1937 Royal Mail Line advertisement for services from Southampton, Liverpool and London to South America.

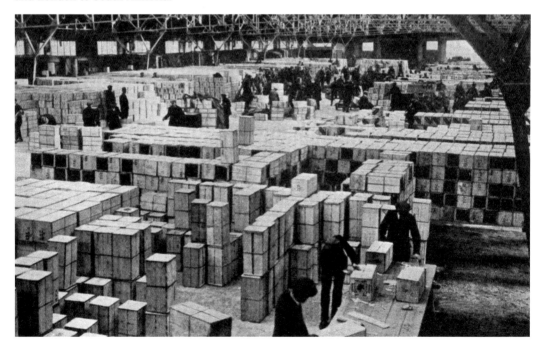

Sorting goods in a warehouse in 1938.

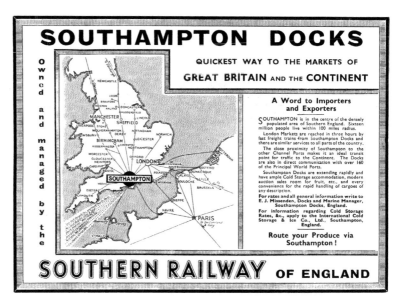

An advertisement for Southern Railway, *c.* 1935.

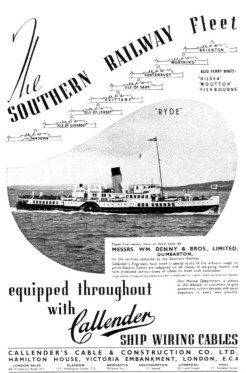

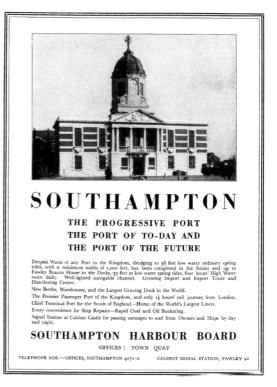

Above left: An advertisement for Callender Ship Wiring Cables in 1937.

Above right: A 1937 Southampton Harbour Board advertisement.

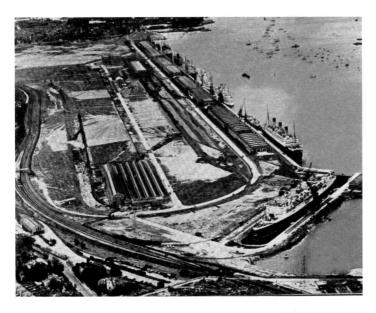

The dock extension in 1938.

ORFORD TWO CLASS CRUISES

CRUISE No. 608 BY S.S. ORFORD 20,000 TONS
21 Days - - - - Fares from £34 First Class, £21 Tourist Class

PORT	ARRIVE		DEPART		STAY HOURS
SOUTHAMPTON	—		Sat. **Aug. 5**	5 p.m.	—
MONTE CARLO	Thur. Aug. 10	11 a.m.	Fri. Aug. 11	8 a.m.	21
NAPLES	Sat. Aug. 12	8 a.m.	Sat. Aug. 12	7 p.m.	11
For Amalfi, Pompeii, etc.					
MESSINA	Sun. Aug. 13	9 a.m.	Sun. Aug. 13	6 p.m.	9
For Taormina.					
VENICE	Tues. Aug. 15	9 a.m.	Wed. Aug. 16	5 p.m.	32
CASABLANCA	Mon. Aug. 21	8 a.m.	Tues. Aug. 22	8 a.m.	24
For Rabat.					
LISBON	Wed. Aug. 23	9 a.m.	Thur. Aug. 24	3 a.m.	18
For Cintra, Estoril, etc.					
SOUTHAMPTON	Sat. Aug. 26	8 a.m	—		—

CRUISE No. 609 BY S.S. ORFORD 20,000 TONS
13 Days - - - - Fares from £22 First Class, £12 Tourist Class

PORT	ARRIVE		DEPART		STAY HOURS
SOUTHAMPTON	—		Sat. **Sept. 2**	5 p.m.	—
LISBON	Tues. Sept. 5	9 a.m.	Wed. Sept. 6	8 a.m.	23
For Cintra, Estoril, etc.					
CASABLANCA	Thur. Sept. 7	8 a.m.	Thur. Sept. 7	7 p.m.	11
For Rabat.					
LAS PALMAS	Sat. Sept. 9	9 a.m.	Sun. Sept. 10	1 a.m.	16
TENERIFFE	Sun. Sept. 10	8 a.m.	Sun. Sept. 10	5 p.m.	9
MADEIRA	Mon. Sept. 11	9 a.m.	Tues. Sept. 12	2 a.m.	17
SOUTHAMPTON	Fri. Sept. 15	8 a.m.	—		—

CRUISE No. 610 BY S.S. ORFORD 20,000 TONS
13 Days - - - - Fares from £22 First Class, £12 Tourist Class

PORT	ARRIVE		DEPART		STAY HOURS
SOUTHAMPTON	—		Sat. **Sept 16**	5 p.m.	—
MONTE CARLO	Thur. Sept. 21	11 a.m.	Fri. Sept. 22	3 a.m.	16
ALGIERS	Sat. Sept. 23	9 a.m.	Sat. Sept. 23	6 p.m.	9
CASABLANCA	Mon. Sept. 25	8 a.m.	Mon. Sept. 25	7 p.m.	11
For Rabat.					
GIBRALTAR	Tues. Sept. 26	8 a.m.	Tues. Sept. 26	Noon	4
SOUTHAMPTON	Fri. Sept. 29	8 a.m.	—		—

These itineraries are subject to variation at the discretion of the Captain

Above left: 1939 Orford cruises from Southampton.

Above right: A 1938 Red Funnel Steamers advertisement.

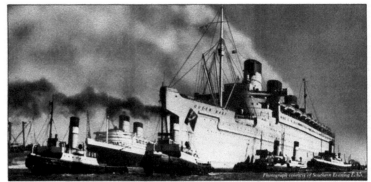

September 1946. Alexandra tugs attending the "Queen Mary" still in her grey wartime dress returning to Southampton after her last voyage as a troopship. She is pictured passing her young sister, the "Queen Elizabeth" looking immaculate in Cunard's traditional black and white dress.

Alexandra are proud to have served Cunard for over 100 years.

An Alexandra Towing Company advertisement.

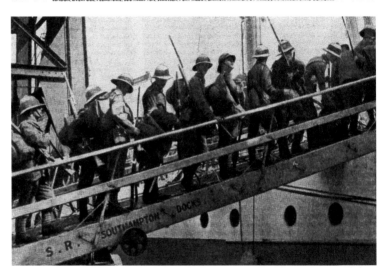

Royal Marines boarding a troopship at Southampton.

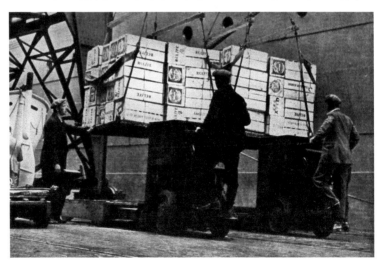

Dock workers unloading cargo of citrus fruits at Southampton.

October 13 1948

A great peacetime fleet

led by the

Atlantic

Queens

Cunard White Star sailings are fast resuming pre-war frequency.

The *Queen Elizabeth* and *Queen Mary*, supported by the *Mauretania*, provide superlative travel comfort on the express service — Southampton, Cherbourg and New York.

On the Liverpool-New York run, the newly-reconditioned *Britannic*, calling regularly at Cobh, operates with two of the new Atlantic liners, *Media* and *Parthia*.

Canada is served by the *Aquitania* from Southampton and the *Ascania* from Liverpool, providing especially for emigrants.

And now the *Caronia* — Britain's new wonder ship, makes her maiden voyage from Southampton, via Cherbourg, to New York on 4th Jan., 1949.

For full information apply Liverpool 3: Pier Head (Central 9201). London S.W.1.: 15 Lower Regent St. (Whitehall 7890). London E.C.3.: 88 Leadenhall St. (Avenue 3010), or principal travel agencies.

Cunard White Star

A 1948 Cunard White Star advertisement.

New Constructions, Conversions, Repairs, Slipways up to 1,200 tons dead-weight. Mud and wet Berths to accommodate vessels of 2,000 tons. Repairs to larger vessels undertaken in the seven dry docks available to all Shipowners at Southampton.

Fixed price quotations. **WHITES SHIPYARD (SOUTHAMPTON) LTD.** *Telephone:* **Southampton 88225**

WHITES SHIPYARD ITCHEN · SOUTHAMPTON

Whites Shipyard, Itchen, in 1949.

Southampton Docks.

 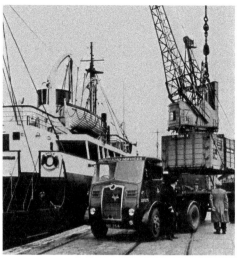

Above left: Harbour Board Offices decorated for the Queen's coronation in June 1953.

Above right: Channel Islands cargo is loaded into a vessel at Southampton Docks.

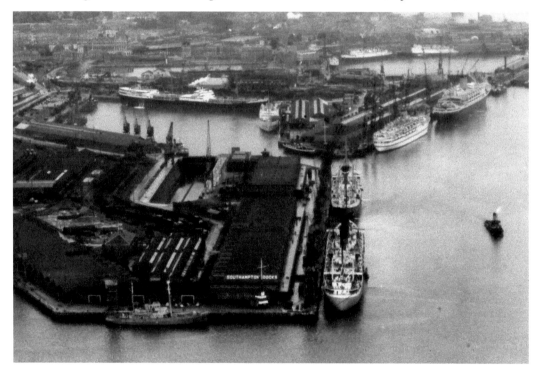

An aerial view of the docks.

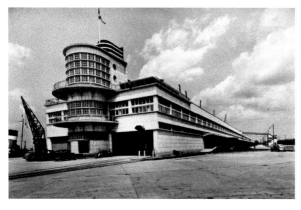

The Ocean Terminal in 1950.

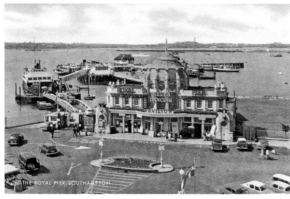

The Royal Pier.

SOUTHAMPTON DOCKS

Britain's Premier Ocean Passenger Port and a leading Cargo Centre

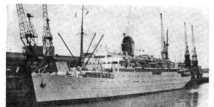

French Line's COLOMBIE at Ocean Terminal, Southampton

- Southampton deals with 54% of Britain's ocean-going passengers
- First-class facilities for freight.
- Sites for industrial development

Enquiries to:—

DOCKS & MARINE MANAGER

SOUTHAMPTON DOCKS

BRITISH TRANSPORT DOCKS

An advertisement for British Transport Docks, *c.* 1955

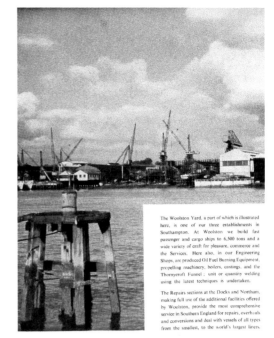

The Woolston Yard, a part of which is illustrated here, is one of our three establishments in Southampton. At Woolston we build fast passenger and cargo ships to 6,500 tons and a wide variety of craft for pleasure, commerce and the Services. Here also, in our Engineering Shops, are produced Oil Fuel Burning Equipment, propelling machinery, boilers, castings, and the Thornycroft Funnel; unit or quantity welding using the latest techniques is undertaken.

The Repairs sections at the Docks and Northam, making full use of the additional facilities offered by Woolston, provide the most comprehensive service in Southern England for repairs, overhauls and conversions and deal with vessels of all types from the smallest, to the world's largest liners.

THORNYCROFT

SHIPBUILDERS
MARINE ENGINEERS
SHIP REPAIRERS

An advertisement for Thornycroft Shipbuilders, *c.* 1957

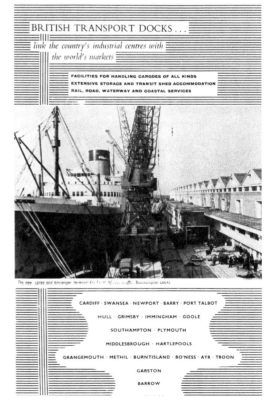

BRITISH TRANSPORT DOCKS...

link the country's industrial centres with the world's markets

FACILITIES FOR HANDLING CARGOES OF ALL KINDS
EXTENSIVE STORAGE AND TRANSIT SHED ACCOMMODATION
RAIL, ROAD, WATERWAY AND COASTAL SERVICES

The new cargo and passenger terminal for South African traffic, Southampton Docks

CARDIFF · SWANSEA · NEWPORT · BARRY · PORT TALBOT

HULL · GRIMSBY · IMMINGHAM · GOOLE

SOUTHAMPTON · PLYMOUTH

MIDDLESBROUGH · HARTLEPOOLS

GRANGEMOUTH · METHIL · BURNTISLAND · BO'NESS · AYR · TROON

GARSTON

BARROW

British Transport Docks, *c.* 1957.

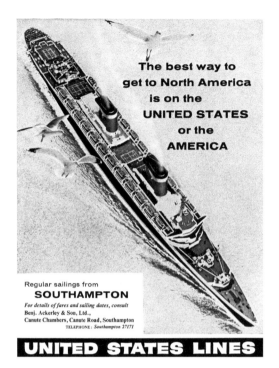
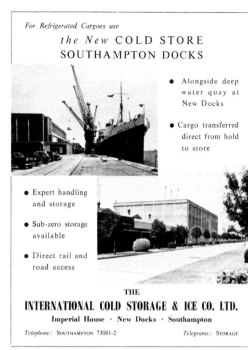
Above left: United States Lines advertisement, 1959.

Above right: International Cold Storage & Ice Company, *c*. 1959.

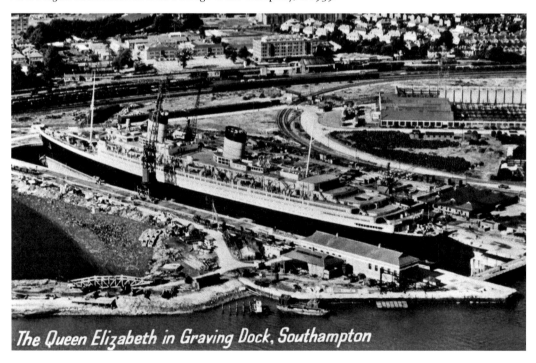

Queen Elizabeth in the King George V Graving Dock.

SUMMARY OF DOCKS AND QUAYS

DOCK OR QUAY	Year opened	Water area	Nominal dredged depth below chart datum	Length of quays	Width of entrance
			ft.	ft.	ft.
NEW DOCKS	1934	—	40	8,014	—
OCEAN DOCK	1911	15½ acres	40	3,807	400
TEST QUAYS AND					
SOUTH QUAY	1902	—	30–32	4,679	—
EMPRESS DOCK	1890	18½ acres	26	3,880	165
ITCHEN QUAYS	1895	—	20–34	3,795	—
OUTER DOCK	1842	16 acres	18	2,621	150

DRY DOCKS

	No. 7 King George V Dock	No. 6 Trafalgar Dock	No. 5 Prince of Wales Dock	No. 4	No. 3	No. 2
Year opened	1933	1905	1895	1879	1854	1847
	ft. in.	ft. in.	ft. in.	ft. in.	ft. in.	ft. in.
Length overall	1,200 0	912 3	745 0	479 9	523 0	281 0
Length at floor level ..	1,141 6	852 0	729 0	451 0	501 0	240 0
Width at entrance ..	135 0	100 0	91 0	55 0	80 0	50 0
Blocks below chart datum	35 6	20 0	18 6	9 9	8 0	1 0
Depth of sill below chart datum	37 6	22 0	22 0	10 10	11 9	1 2

Above left: Port of Southampton.

Above right: Summary of docks and quays in 1959.

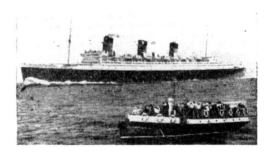
Star Boats harbour cruises from the Royal Pier.

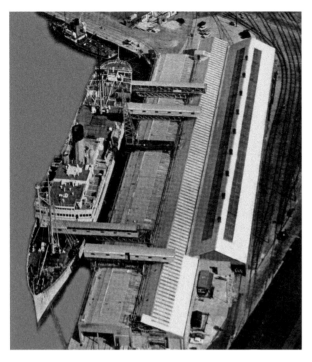

Discharging bananas in 1959.

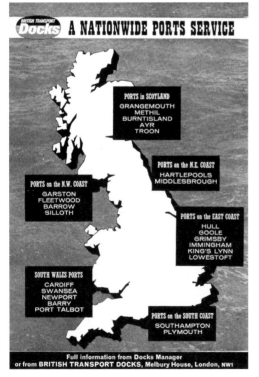

Above left: British Transport Ports, *c.* 1964.

Above right: 1959 advertisements.

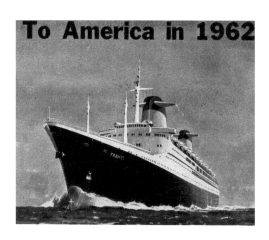

To America in 1962

By the ship of the year

"FRANCE"—the longest liner in the World, makes her Maiden Voyage to New York, February 3rd.

Sailing again on February 23rd and thereafter every other Friday evening from Southampton, arriving New York Wednesday morning—a long weekend. Continental holiday on the way, and the quickest sea service between Southampton and New York.

Enquire of your Travel Agent or

French Line

20 COCKSPUR STREET, LONDON, S.W.1 Telephone TRAfalgar 9040

Right: A 1962 French Line advertisement featuring *France*.

Below: The schedule of outward sailings for P&O's Far Eastern freight services, *c.* 1961.

Peninsular and Oriental Steam Navigation Company NUMBER 14

February 1961

FAR EASTERN FREIGHT SERVICES SCHEDULE OF OUTWARD SAILINGS

Hamburg Rotterdam Antwerp Grangemouth Middlesbrough London Southampton

| | SAILING FROM | | | | | | | DUE AT | | | | | | | |
VESSEL	Hamburg	Rotterdam	Antwerp	Grangemt'h	M'brough	London	So'ton	Penang	Port Swettenham	Singapore	Bangkok	Manila	Hong Kong	Japan	Chin
CORFU						1 Feb	3 Feb	26 Feb		27 Feb				5 Mar	
SOMALI		21 Jan	26 Jan	30 Jan		8 Feb		7 Mar		2 Mar		14 Mar	17 Mar	23 Mar	
SALSETTE		22 Feb	4 Feb			19 Feb	24 Feb	21 Mar	24 Mar	29 Mar	4 Apr	18 Apr	10 Apr		
CHITRAL						28 Feb	2 Mar	24 Mar		25 Mar			31 Mar		
SINGAPORE	9 Feb	21 Feb	23 Feb	27 Feb		7 Mar		7 Apr	2 Apr	28 Mar		14 Apr	17 Apr	23 Apr	
CHUSAN						11 Mar		31 Mar		2 Apr		7 Apr	9 Apr	17 Apr	
CANTON						28 Mar	30 Mar	22 Apr		24 Apr			30 Apr		
SALMARA	23 Feb	17 Mar	14 Mar			30 Mar		25 Apr		27 Apr	3 May	18 May	9 May		
SUNDA	11 Mar	20 Mar	22 Mar	26 Mar		7 Apr		8 May	3 May	28 Apr		15 May	18 May	24 May	
CATHAY						12 Apr	14 Apr	7 May		8 May			14 May	20 May	
COROMANDEL	25 Mar	30 Apr	12 Apr			27 Apr	2 May	30 May		1 June	8 June	18 June	14 June		
SOUDAN	8 Apr	22 Apr	24 Apr	28 Apr		7 May		7 June	? June	29 May		14 June	17 June	23 June	
CHITRAL						17 May	19 May	10 June		11 June			17 June	23 June	
CANNANORE	19 Apr	28 May	7 May			25 May	30 May	29 June		1 July	8 July	18 July	14 July		

With liberty to call at any ports on or off the route and to proceed via Suez, Cape or Panama. The route and date of sailing is subject to change or alteration with or without notice. No cargo to be forwarded without engagement. Refrigerated space available on all vessels. For further details of closing dates and conditions of carriage please see the current sailing cards.

P & O — ORIENT MANAGEMENT LTD.
122 Leadenhall Street, London, EC3. Telephone Avenue 8000. Telex 28624 London

ESCOMBE McGRATH & CO. LTD.
Freight Brokers in the United Kingdom. 4 Lloyds Avenue, London, EC3. Telephone Royal 9181. Telex 28306 London
Also at Birmingham, Grimsby, Immingham, Glasgow, Liverpool, Manchester, Middlesbrough and Southampton

 TO THE FAR EAST

With liberty to proceed via Suez, the Cape or Panama

ss *CANTON*

FOR **PENANG** *due 22nd April*

SINGAPORE *due 24th April*

HONG KONG *due 30th April*

Cargo accepted on through bills of lading for Prai via Penang and Bangkok via Singapore. Refrigerator and cool chamber cargo accepted if inducement.

LOADS	RECEIVES	CLOSES
LONDON No. 9 Berth King George V Dock	20th March	All Ports 24th March
SOUTHAMPTON No. 33 Berth, Old Dock	24th March	All Ports 29th March
Nine Elms Goods Depot SR.	24th March	All Ports 28th March

FOR RATES OF FREIGHT AND CONDITIONS APPLY TO:

P & O London: 122 Leadenhall Street, E.C.3
Tel. Avenue 8000. Tel. Address: Peninsular, London, Telex.

Loading Brokers: **Escombe, McGrath & Co. Ltd.** 4 Lloyds Avenue, E.C.3. Tel. Royal 9181
And at Birmingham, Grimsby, Immingham, Glasgow, Leeds, Liverpool, Manchester, Middlesbrough and Southampton.

AGENTS

Bristol—Van Oppen & Co. (1935) Ltd.
Dundee—Morison, Pollexfen & Blair Ltd.
Glasgow ⎱
Grangemouth ⎰ G.S.N.Co. Ltd., Glasgow
Leicester—Thos. Meadows & Co. Ltd.
Northampton—Morison, Pollexfen & Blair Ltd.
Amsterdam ⎱ General Steam Transport Co.
Rotterdam ⎰ Hoyman Schuurman Ltd.
Antwerp—John P. Best & Co.
Bordeaux—Soc. de Consignation Maritime Franco-Britannique.
Boulogne—Soc. de Consignation Maritime Franco-Britannique.
Bremen—General Steam Navigation Co. Ltd.
Tonnay-Charente—Renault-Delage.

Copenhagen—Nordisk Express.
Dunkirk—Soc. de Consignation Maritime Franco-Britannique.
Gothenburg—Nordisk Express.
Hamburg—General Steam Navigation Co.
Havre—Soc. de Consignation Maritime Franco-Britannique.
Marseilles—Estrine & Co.
Oslo—Halle & Petersen.
Paris—Hernu Peron (France) S/A.
Prague—Czechoslovak Shipping Co. Ltd.
Stockholm—Nordisk Express.
Genoa—Joint Agency.
Basle ⎱
Zurich ⎰ Jacky Maeder & Co.

No cargo to be forwarded without engagement. With liberty to call at any ports on or off the route—and the route and sailing is subject to change or amendment with or without notice.
Licensed Cargo must be pre-entered and the necessary Customs Papers available at port of shipment prior to the delivery of the goods. All Licensed goods must be clearly marked " LICENSED " in red lettering, at least two inches high on the same side of the package as the Shipping Mark.

For other clauses see overleaf

P&O *Canton* sailing list.

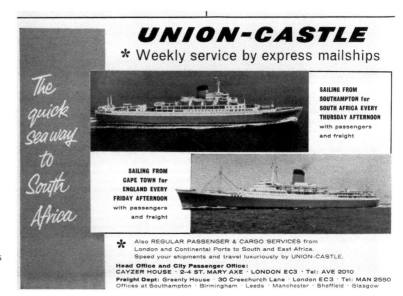

Union Castle Line – weekly service by express mail ships, c. 1961.

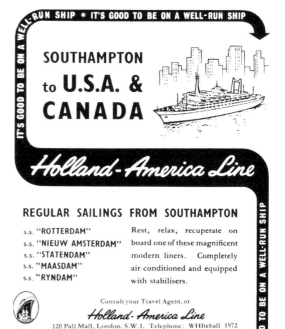
Above left: United States Line services, c. 1966.

Above right: Holland America Line services from Southampton, c. 1962.

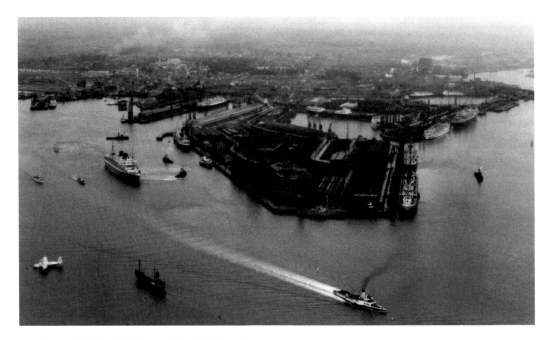

UNION-CASTLE LINE
ROYAL MAIL SERVICE TO SOUTH AFRICA

R.M.M.V.
"STIRLING CASTLE"
(Berth 104)

Sailing from SOUTHAMPTON on Thursday, 16th MAY, is expected to take cargo arriving alongside up to the evening of Tuesday, 14th MAY for :—

				Arriving
MADEIRA	19 MAY
CAPE TOWN	30 MAY
PORT ELIZABETH	1 JUNE	
EAST LONDON	3 JUNE	
DURBAN	4 JUNE
MOSSEL BAY	9 JUNE

also by transhipment for Walvis Bay, Luderitz Bay, Lourenco Marques, Beira and Mauritius.

All Shippers are recommended to despatch cargo by Thursday, or not later than Friday, to ensure its arrival at Southampton by Monday at the latest.

Following Mail Sailings from Southampton :—
R.M.S. " WINDSOR CASTLE " .. *Thursday, 23rd MAY*
R.M.S. " PRETORIA CASTLE " ... *Thursday, 30th MAY*

GREENLY HOUSE.
30, Creechurch Lane, E.C.3.
2nd May, 1963.
AVENUE 4343

UNION-CASTLE LINE TO SOI

Above: Willem Ruys (1947/23,478 grt) leaving Southampton.

Left: Union Castle Line's *Stirling Castle* (1936/25,550 grt).

58

Right: Red Funnel Steamers' special cruises from Southampton for Easter 1962.

Below: *Northern Star* sailed on her maiden voyage from Southampton on 10 July 1962 with over 1,400 passengers and 480 crew on board. She was employed with her sister, *Southern Cross,* on round-the-world voyages until she was withdrawn from service in 1975, when she was sold to the shipbreakers. She arrived at Taiwan on 11 December that year to be broken up.

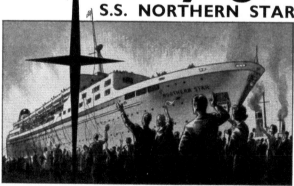

SHAW SAVILL LINE

STEAMSHIP

NORTHERN STAR
22,000 TONS G.R.T.

SOUTHAMPTON
FOR

Las Palmas, Cape Town, Durban,
Fremantle, Melbourne, Sydney,
New Zealand (Wellington or Auckland),
Fiji, Tahiti, Panama, Curacao, Trinidad
AND
SOUTHAMPTON

TO BE LAUNCHED AT
VICKERS-ARMSTONGS NAVAL YARD, NEWCASTLE-ON-TYNE
ON JUNE 27th, 1961
JOINS HER FAMOUS SISTER SHIP SOUTHERN CROSS IN THE
ROUND THE WORLD SERVICE
IN JULY, 1962

FOR BOOKINGS, FARES ETC. APPLY TO:
SHAW SAVILL & ALBION CO., LIMITED,
IIA, LOWER REGENT ST., LONDON, S.W.I. Telephone WHI 1485
OR TO
GRACIE, BEAZLEY & CO.,
12, WATER ST., LIVERPOOL. Telephone CEN 4611
ATTENTION IS DRAWN TO THE INFORMATION ON THE BACK OF CARD.
20.6.61

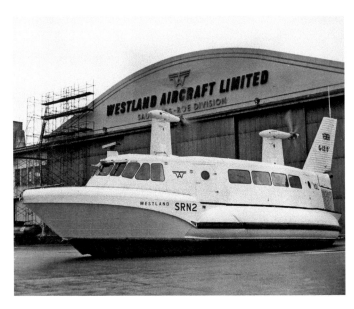

Above left: Shaw Savill Line, *Northern Star*'s maiden voyage sailing list.

Above right: The Westland/Saunders-Roe SR.N2 hovercraft first flew in 1961. It was 27 tons and carried forty-eight passengers. Southdown Motor Services and Westland Aircraft ran the SR.N2 on the Solent between Eastney and Ryde in 1963/64, carrying 30,000 passengers.

ROUTE OF "NORTHERN STAR" AND "SOUTHERN CROSS"

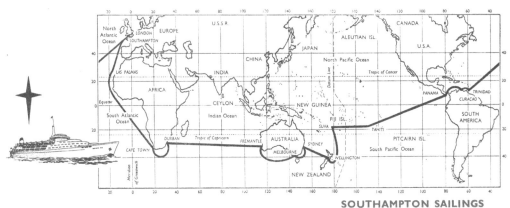

SOUTHAMPTON SAILINGS

"Southern Cross"	—	7 Sept.	1961	— Eastabout
"Southern Cross"	—	5 Dec.	1961	— Westabout
"Southern Cross"	—	I Mar.	1962	— Westabout
"Southern Cross"	—	24 May	1962	— Eastabout
"Northern Star"	—	10 July	1962	— Eastabout
"Southern Cross"	—	6 Sept.	1962	— Eastabout
"Northern Star"	—	6 Oct.	1962	— Eastabout
"Southern Cross"	—	4 Dec.	1962	— Westabout

TO OUR FREIGHT SUPPORTERS

We thought that you would like to know about "Northern Star" even though she does not carry cargo.

Northern Star and *Southern Cross* sailing details, 1961/62.

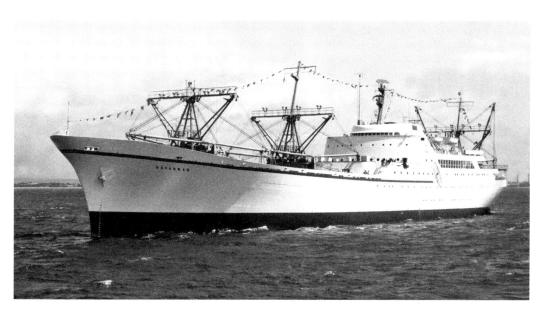

Above: The nuclear-powered merchant vessel *Savannah* (1962/13,599grt) at Southampton on 11 July 1964. She was at the port for six days during a voyage to Europe which also included calls at Dublin, Bremerhaven and Hamburg. She was operated by American Export-Isbrandsten Lines Incorporated and left Galveston on May 5 to visit Houston, New Orleans, Baltimore, Boston and New York before crossing the Atlantic. (Barry Eagles)

Right: The troopship *Oxfordshire* (1957/23,180 grt) in dry dock at Southampton. (Barry Eagles)

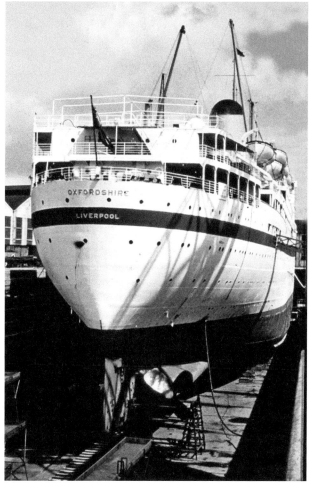

A NEW CONCEPT IN SHIP DESIGN

'CARMANIA' AND 'FRANCONIA' EQUIPPED FOR DUAL-PURPOSE ROLE

The conversion of the 'Carmania' and 'Franconia' into dual-purpose Atlantic liners and cruise ships has been one of the most important jobs undertaken in British shipyards in recent months. It has equipped the two sister ships with new public rooms, complete new decor and lighting schemes, private baths or showers throughout practically the whole of the passenger accommodation, complete air-conditioning, and a gay new lido deck.

Now among the best-equipped cruise ships afloat and with accommodation up to highest standards of the North Atlantic trade, they mark the achievement of a brilliant new look in ship design.

Together, they will maintain a new Cunard service, linking Rotterdam and Southampton with Quebec and Montreal, and calling regularly at Havre and Cobh.

Cunard sailings from Liverpool and Greenock to the St. Lawrence ports are maintained by the 22,000 ton 'Carinthia'.

CUNARD

Consult your local travel agent or CUNARD LINE, Cunard Building, Liverpool 3 (Liverpool CENtral 9201); 15 Lower Regent Street, London, S.W.1 (WHItehall 7890); 88 Leadenhall Street, London, E.C.3 (AVEnue 3010).

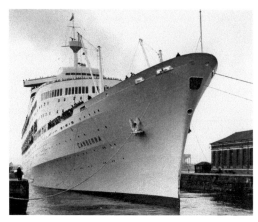

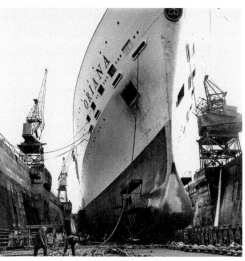

Above left: *Carmania* was built as *Saxonia* at the yard of John Brown & Company on the Clyde. She was launched by Lady Churchill on 17 February 1954 and sailed on her maiden voyage from Liverpool to Montreal on 2 September that year. She was the first of four sisters built for the Cunard Line service to Quebec and Montreal. In 1961 she was employed on the London–New York service and cruised out of Port Everglades in the winter months. She returned to her builders in 1962 to be converted to a dual-purpose North Atlantic and cruise liner, being painted Caronia green and renamed *Carmania*. Between 1964 and 1970 she was employed on 'fly cruises' in the Mediterranean in the summer and Caribbean cruises in the winter months, and was painted white in 1967. *Carmania* was laid up at Southampton in 1971 and was moored in the River Fal in 1972. She was sold to Nikreis Maritime Corporation in 1973 and renamed *Leonid Sobinov*, being managed by CTC Lines for the Southampton to Australia and New Zealand service and for cruising duties. On 24 November 1975 she was the first passenger liner to pass through the newly re-opened Suez Canal following its clearance after the 1967 war. After the invasion of Russian troops into Afghanistan she was precluded from operating from Australia in 1979 and operated services for the Russian Far East Shipping Company. As *Leonid Sobinov* she operated a variety of services and cruises until 1999, when she was delivered to Indian shipbreakers at Alang on 1 October that year. She had been anchored off Alang since 1 April. (Barry Eagles)

Above right: *Canberra* (1961/45,270 grt) and *Oriana* (1960/41,910 grt) in dry dock at Southampton.

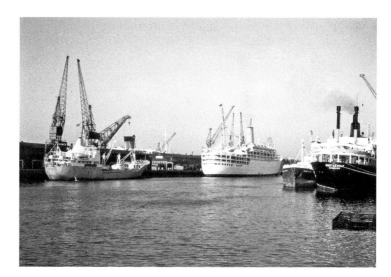

The Ocean Dock.

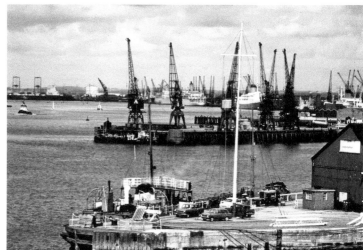

Southampton Docks
in the late 1960s.

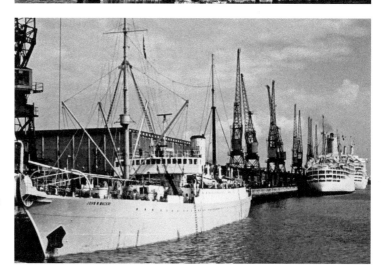

The cable ship *John
W. Mackay* (1922/4,160
grt). She arrived
at Alang on 25
March 1994 and was
broken up.

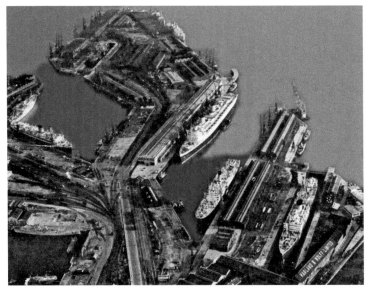

Ocean Dock, with
the *Queen Elizabeth*
alongside the Ocean
Terminal. Empress
Dock is on the left
and is a part of the
Inner Dock.

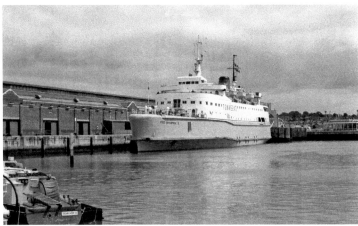

Free Enterprise II
(1965/4,011 grt) at the
car ferry berth in the
Outer Dock.

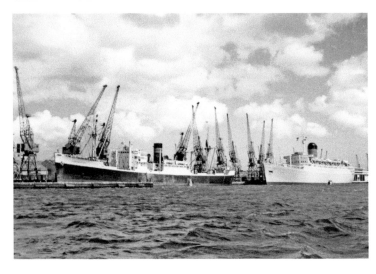

Clan Macdougall
(1944/9,710 grt)
and *Franconia*
(1955/22,637 grt).

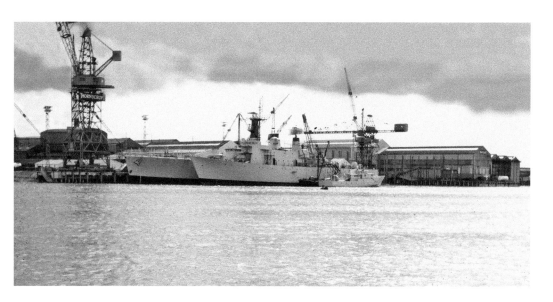

Thornycroft's yard at Woolston on 27 March 1967, with *Juno*, *Abdiel* and a Libyan vessel. (Bert Moody Collection).

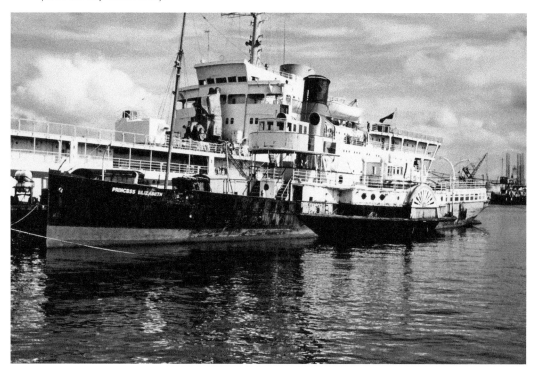

Princess Elizabeth (1927/371 grt) was the last vessel to be built by Day, Summers & Company Limited of Southampton and served the Red Funnel fleet for thirty-three years. Throughout her career she was principally used for summer excursions from Southampton and Southsea to the Isle of Wight piers and made occasional trips to Bournemouth, Swanage and Bognor. Occasionally she was operated on the Southampton–Cowes ferry service. She was sold in 1959 to Torbay Steamers Limited, and now operates as a restaurant at Dunkirk.

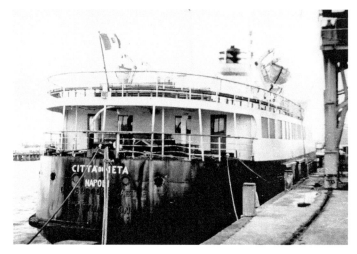

Carisbrooke Castle became *Citta di Meta* in 1974.

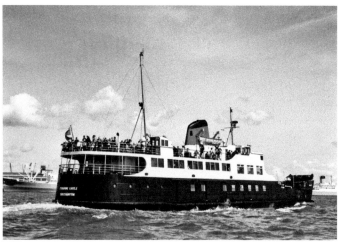

Osborne Castle
(1962/736 grt).

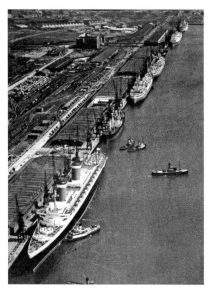

United States berths at Southampton following a transatlantic voyage from New York.

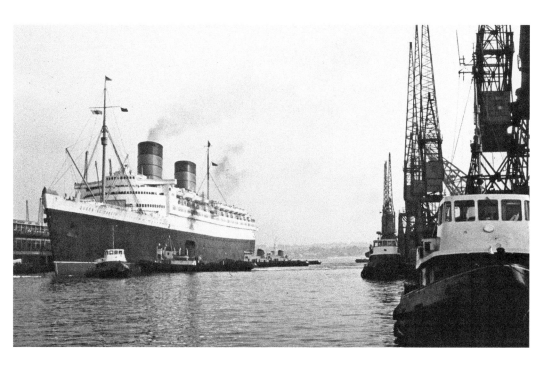

Above: *Queen Elizabeth* arriving at Southampton.

Below left: Harland & Wolff Limited, Southampton.

Below right: A cargo of lamb is unloaded into the cold store.

ABSTRACT OF LOG OF THE
Cunard Liner R.M.S. "MAURETANIA"
CAPTAIN J. TREASURE JONES, R.D., R.N.R.

Date 1965			Distances	Latitude	Longitude	WEATHER
				N	W	
Wednesday	Mar.	10				At 23.31 G.M.T. left Berth 46, Southampton
Thursday	,,	11				At 01.36 G.M.T. Needles abeam DEPARTURE
Thursday	,,	11	217	48.12	05.42	Rough sea, moderate SE'ly swell, cloudy and clear
Friday	,,	12	507	40.26	09.40	Moderate SW sea and swell, cloudy and clear
Saturday	,,	13	388	To	Tangier	At Tangier 07.00 L.T. (07.00 G.M.T.) ARRIVAL
			1112			PASSAGE—2 days, 5 hrs., 24 mins. Average Speed 20.82 knots
						Reduced Speed—19 hrs., 00 mins.
Sunday	,,	14				Left Tangier 02.16 L.T. (02.16 G.M.T.) DEPARTURE
Sunday	..	14	206	36.50	01.50	Calm sea, cloudy and clear
Monday	,,	15	337	To	Barcelona	At Barcelona 06.30 L.T. (05.30 G.M.T.) ARRIVAL
			543			PASSAGE 1 day, 3 hrs., 14 mins. Average Speed 19.94 knots
						Reduced Speed—7 hrs., 06 mins.
Monday	,,	15	380			Left Barcelona 18.36 L.T. (17.36 G.M.T.) DEPARTURE
Tuesday	,,	16		To	Livorno	At Livorno 11.42 L.T. (10.42 G.M.T.) ARRIVAL
			380			PASSAGE—17 hrs., 6 mins. Average Speed 22.22 knots
						Reduced Speed—3 hrs., 00 mins.
					E	
Wednesday	,,	17		41.12	12.03	Left Livorno 01.15 L.T. (00.15 G.M.T.) DEPARTURE
Wednesday	,,	17	179			Smooth sea, low swell, cloudy with showers
Thursday	,,	18	298	To	Catania	At Catania 07.24 L.T. (06.24 G.M.T.) ARRIVAL
			477			PASSAGE—1 day, 6 hrs., 09 mins. Average Speed 15.82 knots
						Reduced Speed—12 hrs., 54 mins.
Thursday	,,	18		38.41	09.52	Left Catania 20.09 L.T. (19.09 G.M.T.) DEPARTURE
Friday	,,	19	331			Rough sea, mod. W'ly swell, mainly overcast and clear
Saturday	,,	20	349	To	Palma	At Palma 07.00 L.T. (06.00 G.M.T.) ARRIVAL
			680			PASSAGE—1 day, 10 hrs., 51 mins. Average Speed 19.51 knots
						Reduced Speed—20 hrs., 45 mins.
					W	
Saturday	,,	20		36.34	02.34	Left Palma 22.24 L.T. (21.24 G.M.T.) DEPARTURE
Sunday	,,	21	311			Calm and rippled sea, fine and clear
Sunday	,,	21	140	To	Gibraltar	At Gibraltar 18.36 L.T. (17.36 G.M.T.) ARRIVAL
			451			PASSAGE—20 hrs., 12 mins. Average Speed 22.33 knots
						Reduced Speed—Nil
Sunday	,,	21		38.44	09.41	Left Gibraltar 21.48 L.T. (20.48 G.M.T.) DEPARTURE
Monday	,,	22	310	47.00	06.45	Long mod. NW'ly swell, slight sea, o'cast, then cloudy and clear
Tuesday	,,	23	523			Rough sea, heavy W'ly swell, mainly overcast and clear
Wednesday	,,	24	303	To	Southampton	At 04.42 B.S.T. (03.42 G.M.T.) Needles abeam— ARRIVAL
			1136			PASSAGE—2 days, 6 hrs., 54 mins Average Speed 20.89 knots
						Reduced Speed—20 hrs., 17 mins.

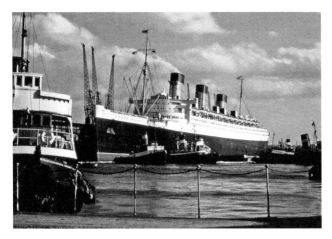

Above: The abstract of the log of the *Mauretania*, March 1965.

Left: *Queen Mary* is assisted by tugs at the start of a voyage to New York.

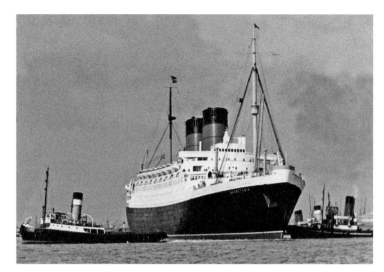

Mauretania
(1939/35,739 grt).

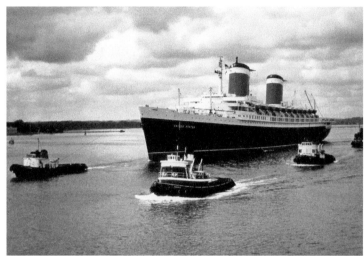

United States
(1952/53,330 grt) in
Southampton Water.

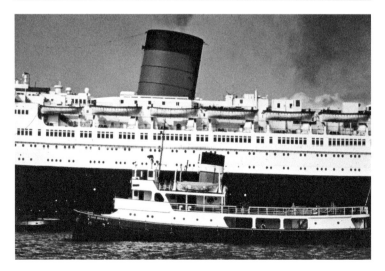

Flying Breeze
(1938/460 grt) assists
Queen Elizabeth at
Southampton.

69

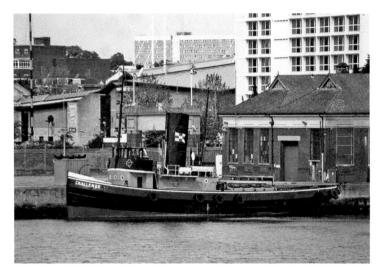

The tug *Challenge* (1931/212 grt) at Southampton.

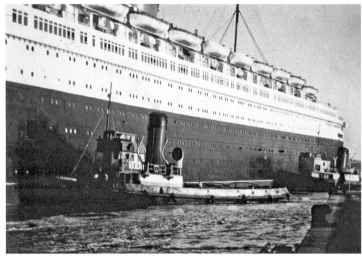

Clausentum (1926/268 grt).

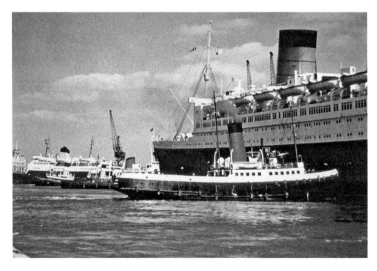

Calshot (1930/701 grt) assisting *Queen Elizabeth.*

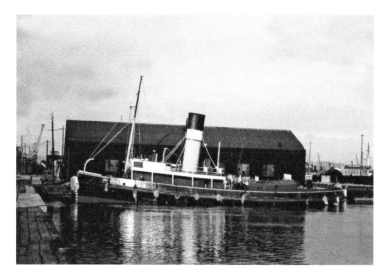

Alexandra towing tug *Murton* (1929/186 grt) was built as *Ceemore*, becoming *Murton* in 1959, and was broken up at Briton Ferry in 1964.

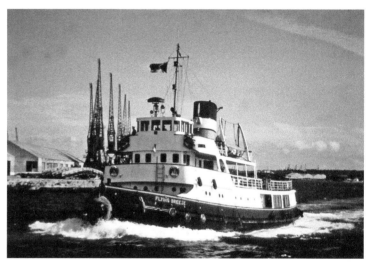

Flying Breeze (1938/460 grt).

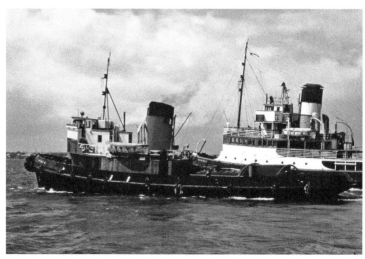

Sir Bevois (1953/318 grt) and *Romsey* (1930/509 grt). (Barry Eagles)

71

HOME FIT FOR A QUEEN

Southampton is to be the home port for Cunard's new super luxury liner, QE2.

It's an obvious choice: Southampton is on the main route to America, it's convenient for the Continent, there are no locks and no tidal restrictions, and access by road and rail is quick and easy. These are factors which have also made Southampton one of Britain's major cargo ports, with a fast growing container traffic.

To stay ahead of the demands of cargo shippers, the Docks Board has embarked on a multi-million pound development scheme for the port which will enhance its reputation for speedy turnround and efficient handling.

For further information contact the Chief Docks Manager, Dock House, Canute Road, Southampton IPZ. Telephone : 23844 ; or the Marketing Manager, British Transport Docks Board, Melbury House, Melbury Terrace, London N.W.1. Telephone : 01-486 6621.

Passenger terminal at berth 43, Southampton Docks which will be used by the QE2

S⊇ British Transport Docks Board Southampton

An advertisement for the British Transport Commission, c. 1969.

Bon Voyage

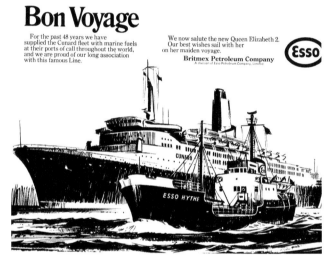

For the past 48 years we have supplied the Cunard fleet with marine fuels at their ports of call throughout the world, and we are proud of our long association with this famous Line.

We now salute the new Queen Elizabeth 2. Our best wishes sail with her on her maiden voyage.

Britmex Petroleum Company
A division of Esso Petroleum Company, Limited

(Esso)

An Esso advertisement, c. 1969.

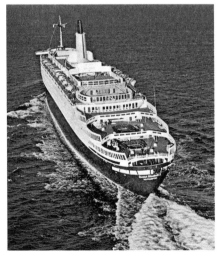

Queen Elizabeth 2 was built by John Brown & Company on the Clyde and was launched by Her Majesty Queen Elizabeth on 20 September 1967. She was employed on transatlantic crossings and also undertook cruises. In 1982 she participated in the Falklands Conflict and carried over 3,000 troops to the South Atlantic. She was converted from steam to diesel power in 1986/87 and the passenger accommodation was refurbished. When the line was purchased by the Carnival Corporation in 1999, the *QE2* received a $30 million refurbishment. She was acquired by Nakheel on 27 November 2008 and was laid up at Port Rashid in 2011. She was handed over to Nakheel at Dubai and is now used as a hotel, restaurant and entertainment complex.

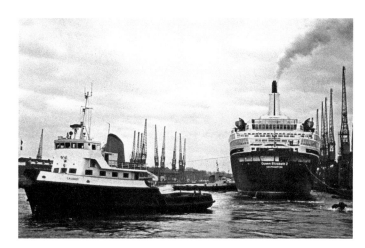

Calshot (1964/475 grt) helps berth *Queen Elizabeth 2.*

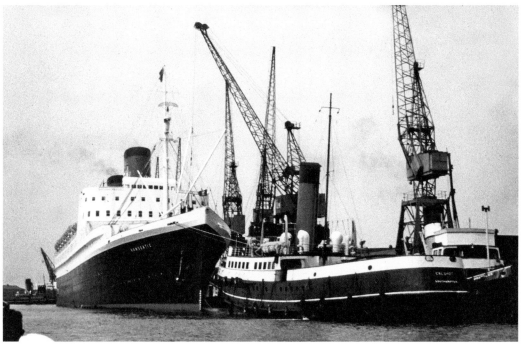

Hanseatic, Calshot and *Brambles. Hanseatic* was launched as *Empress of Japan* for the Canadian Pacific Vancouver to Yokohama service by Fairfield at Glasgow. Her maiden voyage was from Liverpool to Quebec on 14 June 1930. Returning to Southampton, she sailed on 12 July to Suez, Hong Kong, Yokohama and Vancouver. In 1939 she was requisitioned as a troop carrier and in 1942 she was renamed *Empress of Scotland*. Released from war duties on 3 May 1948, she was refitted at Glasgow and Liverpool and sailed on her first post-war voyage from Liverpool to Quebec on 9 May 1950. Her masts were shortened in 1952 to allow her to pass under the Quebec Bridge and sail to Montreal. In 1958 she was sold to the Hamburg-Atlantic Line, being renamed *Hanseatic* and sent to be refitted and modernised by Howaldt at Hamburg. On 19 July 1958 she sailed from Hamburg, Havre and Southampton to New York and operated cruises during the winter months. She caught fire at New York on 7 September 1966 and was badly damaged. *Hanseatic* was towed to Hamburg and was sold for scrap and broken up by Eisen & Metall AG at Hamburg.

Alexandra and Southampton, Isle of Wight & South of England Steam Packet Company tugs at Southampton.

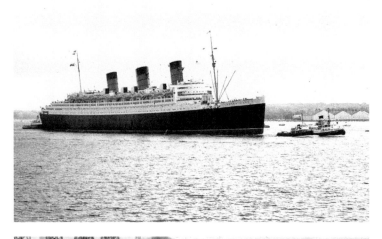

Queen Mary arrives at Southampton at the end of a North Atlantic crossing in September 1966.

Queen Elizabeth awaits passengers at Southampton.

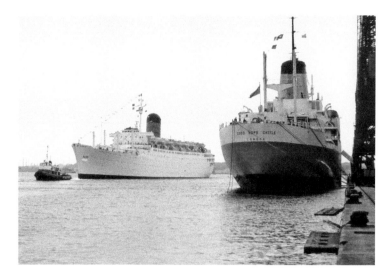

Carmania and
Good Hope Castle
(1965/10,538 grt).

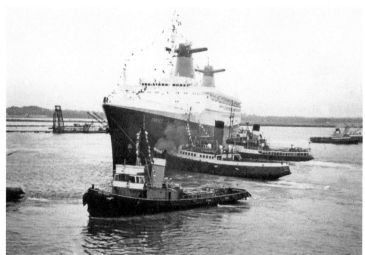

France
(1962/66,343 grt).

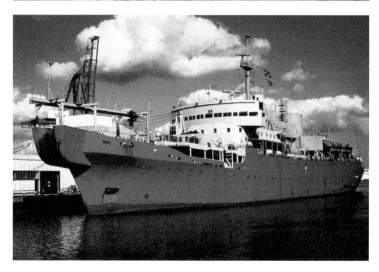

C S Alert
(1960/6,083 grt).

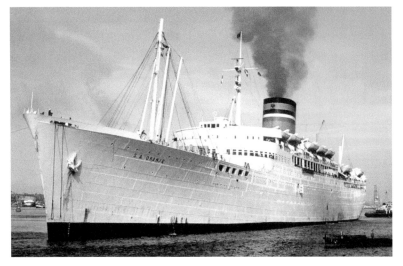

SA Oranje (1948/28,705 grt) was built as *Pretoria Castle* for the Union Castle Line. She was transferred to the South African Marine Corporation in 1966 and renamed *SA Oranje*. She was broken up in 1975.

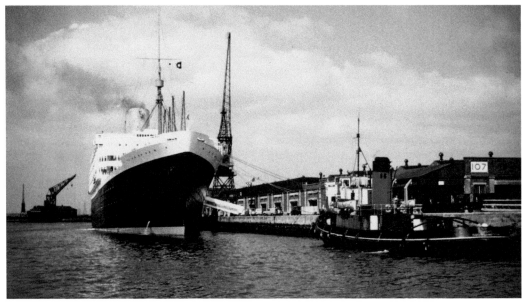

Andes was a product of Harland & Wolff at Belfast and was launched on 7 March 1939. She was due to make her maiden voyage on the 100th anniversary of the Royal Mail Lines but was ordered to sail to Liverpool, where she was converted to a troopship. In May 1945 she carried the Norwegian Government back to Oslo and was returned to her builders to be prepared for peacetime service, sailing on 22 January 1948 on her first commercial voyage to South America. In 1959 she was converted to a one-class vessel and sailed on her first cruise in June the following year. *Andes* was advertised as being: 'Not just another passenger liner that converts to cruising for a few months each year. A 27,000-ton ship, she has a crew of 460 men and women, devoted entirely to cruising, indeed dedicated to make sure that your cruise is the most memorable holiday of your life.' She boasted 40,000 square feet of open deck, an outdoor swimming pool, a golf net for practising, a 250-seat air conditioned cinema, bridge in the Warwick Room, dancing, bingo and deck games. The 1970 brochure claimed that: 'You can do and get pretty well anything you want in *Andes*, within the limits of decency, that is!' She was a popular and successful cruise ship and survived until 1971, when she was sold and broken up at Ghent.

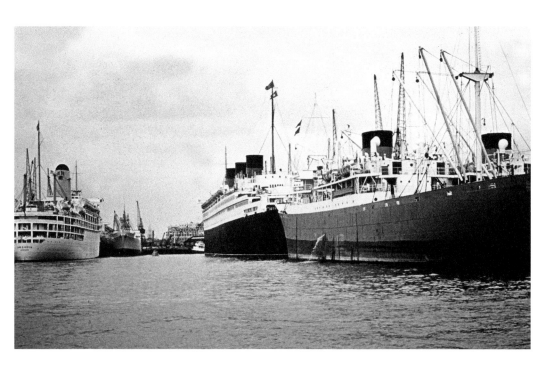

The cargo vessels *Arcadia, Queen Mary* and *Union Castle*.

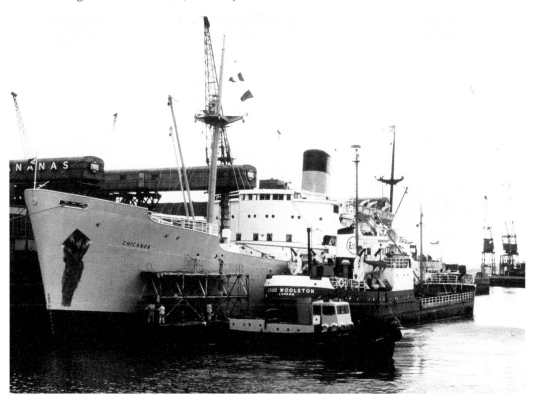

Elders & Fyffes' *Chinanoa* (1958/6,095 grt).

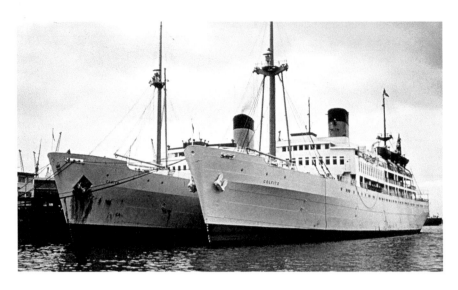

Above and below: Elders & Fyffes operated a service from Southampton to Bermuda, Jamaica, Antigua and Trinidad, and was formed in 1901 to transport bananas from the West Indies to the United Kingdom. Elders & Fyffes continued in this trade until their withdrawal from shipping in the early 1970s, and the last two ships they owned were the *Golfito* and *Camito*. Gordon Holman, author of *The Little Ships,* described these two ships as being: 'Neither too large nor too small when a double crossing of the Atlantic is involved. A floating island of this size, with comfortable accommodation for slightly less than 100 passengers, must have the personal touch. The white painted liners belonging to Fyffes Line, a name which should indicate in which direction you will be going to get away from it all. In ten days you are in the Caribbean, with Jamaica as your turnaround point after a brief stay.'

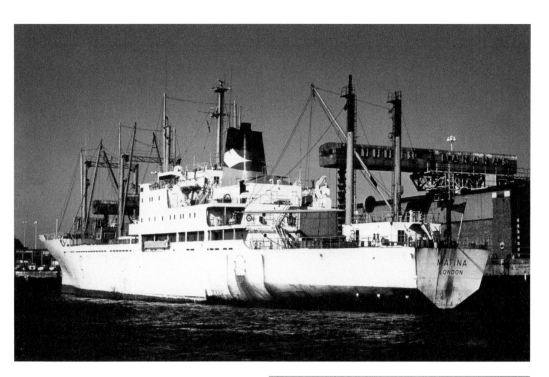

Above: *Matina* (1969/6,085 grt).

Right: Elders & Fyffes' *Camito* (1956/8,687 grt).

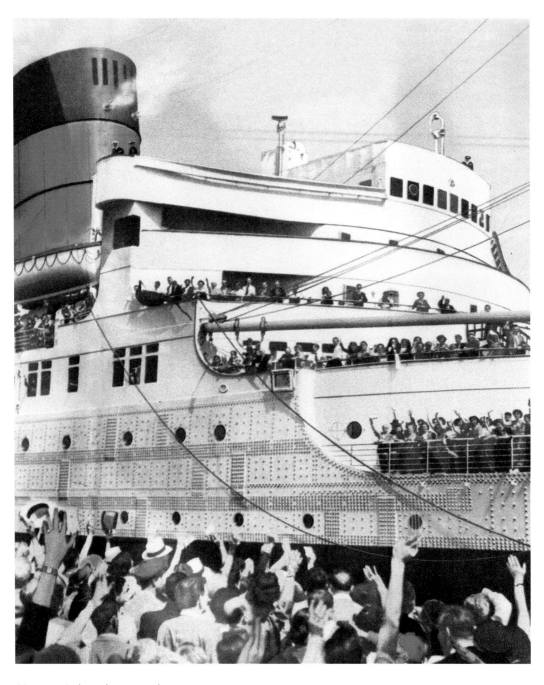

Mauretania (1939/35,739 grt).

Above and below: *Caronia* laid up at Southampton. (Barry Eagles)

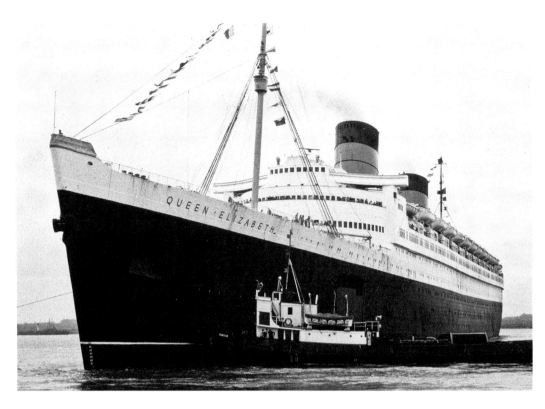

Queen Elizabeth's final departure from Southampton. (Barry Eagles)

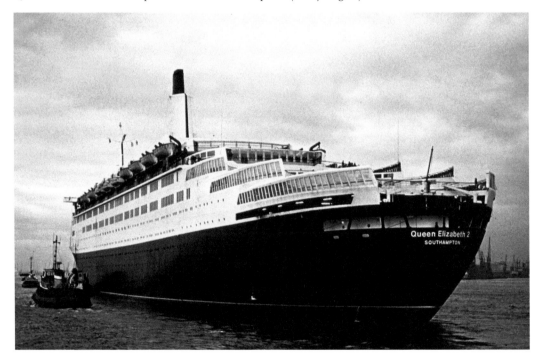

Queen Elizabeth 2's arrival at Southampton from her builders. (Barry Eagles)

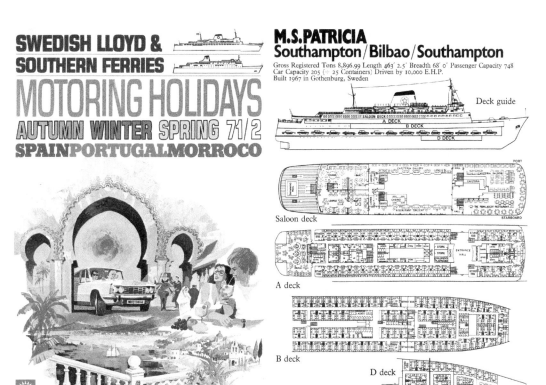

SWEDISH LLOYD & SOUTHERN FERRIES
MOTORING HOLIDAYS
AUTUMN WINTER SPRING 71/2
SPAIN PORTUGAL MORROCO

autolloyd—the best in motoring holidays

M.S.PATRICIA
Southampton/Bilbao/Southampton

Gross Registered Tons 8,896.99 Length 463′ 2.5′ Breadth 68′ 0′ Passenger Capacity 748
Car Capacity 205 (+ 25 Containers) Driven by 10,000 E.H.P.
Built 1967 in Gothenburg, Sweden

Deck guide

Saloon deck

A deck

B deck

D deck

A and C are lower berths

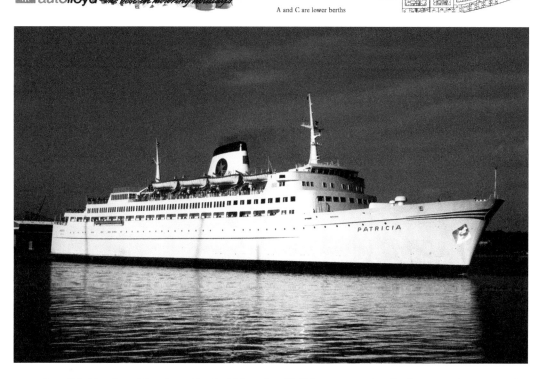

Swedish Lloyd and Southern Ferries' Motoring Holidays, c. 1971/72. Both companies operated a joint service from Southampton to Spain, Portugal and Morocco in 1971–72.

Carmania and *Franconia* laid up at Southampton. (Barry Eagles)

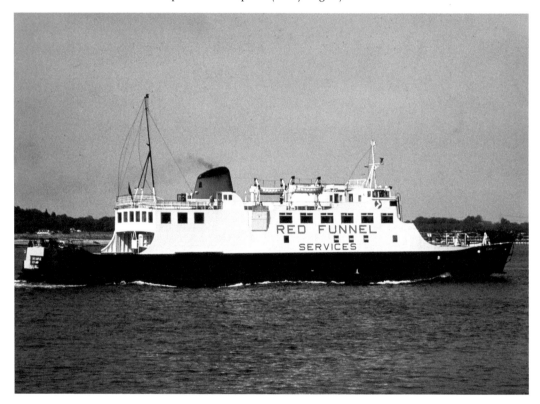

Red Funnel's *Cowes Castle* (1965/1,433 grt).

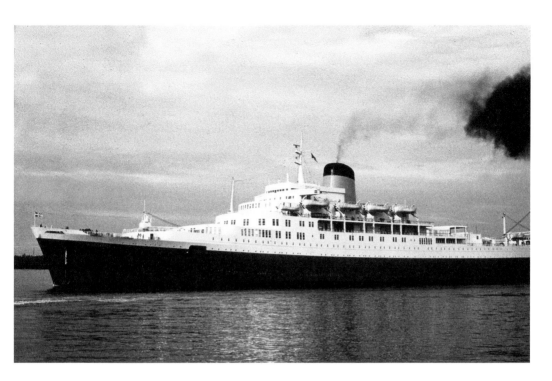

Margarita L (ex-*Windsor Castle*) leaves Southampton for the last time on 3 October 1977.

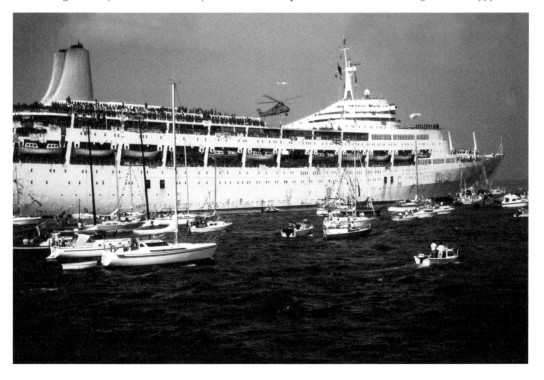

Canberra returns from the Falklands on 11 July 1982, showing a helicopter of the Queen's Flight with HRH Prince Charles on board.

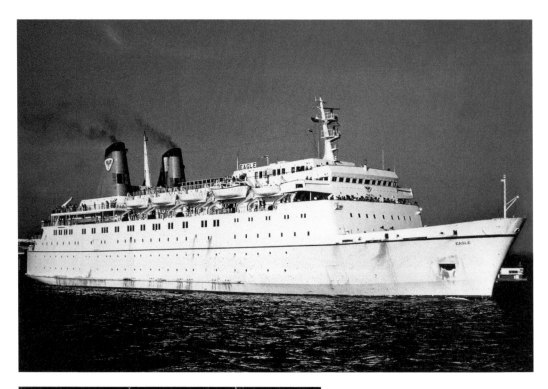

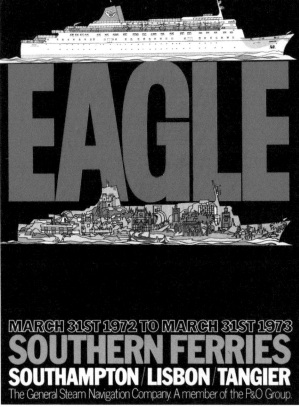

Above and left: 'Cruise down to Tangier on *Eagle*.' *Eagle* was owned by the General Steam Navigation Company's Southern Ferries and was specifically built in 1971 for a service to Spain, Portugal and Morocco. The service initially proved popular and successful. However, after operating for only five seasons and following political unrest in Portugal it was decided to sell the vessel to Compagnie de Paquebots in October 1976. She was renamed *Azur*, later *The Azur,* and was converted to a cruise ship in 1981, with additional cabins fitted to her former garage deck. She was chartered to Chandris from 1987 to 1994 and was later operating for Festival Cruises. Since 2004 she has been operating for Mano Maritime of Israel as *Royal Iris*, with *Golden Iris*, previously *Cunard Princess,* and *Rhapsody*.

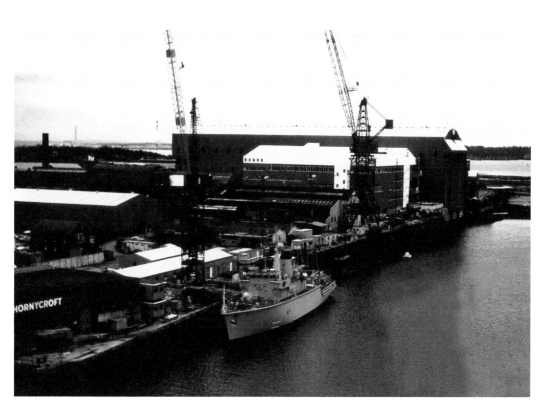

HMS *Brecon* at J. I. Thornycroft's, Woolston, on 1 December 1979.

The Royal Fleet Auxiliary tanker *Olna* (1966/36,027 grt).

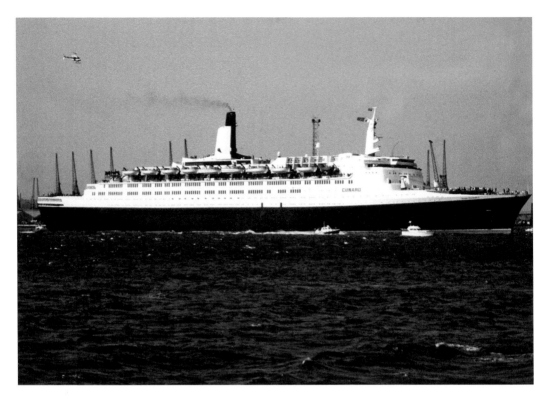

Queen Elizabeth 2 leaves Southampton for the Falklands on 12 May 1982. (Barry Eagles)

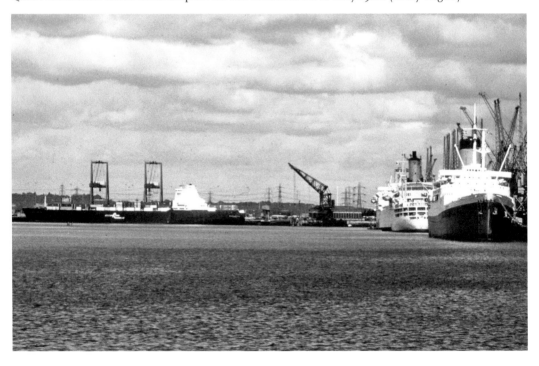

Southampton Docks.

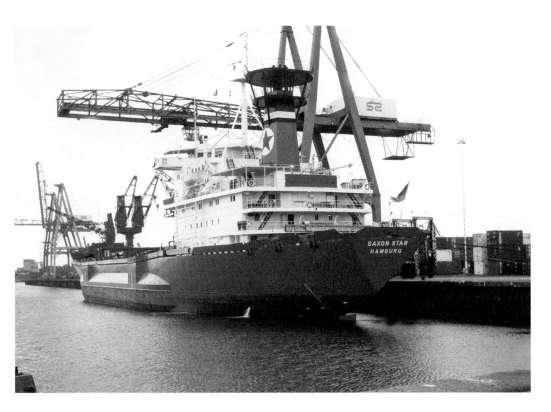

Saxon Star (1975/12,549 grt).

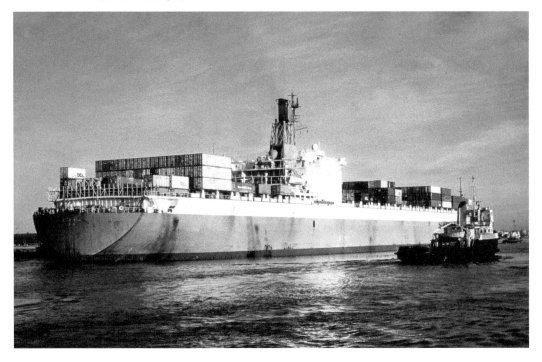

Benalder (1972/55,889 grt).

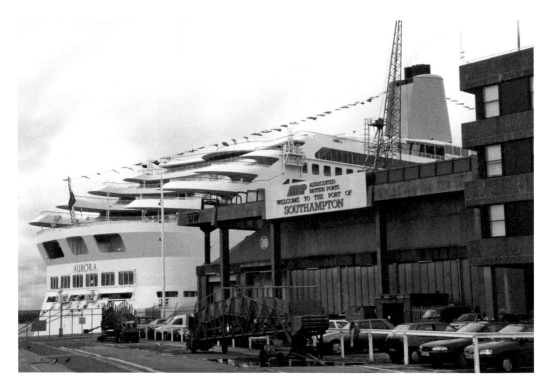

P&O's *Aurora* at Berth 38. *Aurora* was built by Meyer Werft at Papenburg for P&O Cruises and was named by Princess Anne on 27 April 2000. *Oriana* and *Aurora* were both designed and built for the British cruise market and were to also undertake world cruises each year. At the time of the attack on the World Trade Center at New York on 11 September 2001, *Aurora* was operating 80 miles away for a conference of IT personnel. Following the attacks *Aurora* was briefly protected by US Coastguard helicopters and was unable to return to her berth at Pier 53 in Manhattan. She was diverted to Boston, where her passengers were finally disembarked. Many of the people on board were in touch by phone with staff in Tower 1 and Tower 2, and would normally have been working at the World Trade Center.

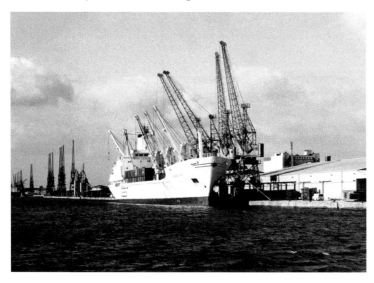

Geestacape
(1976/10,808 grt).

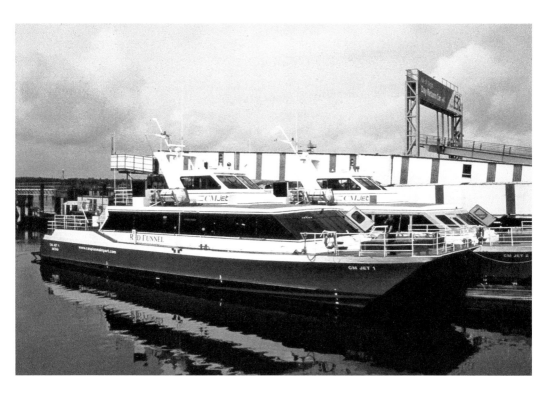

CM Jet 1 and *CM Jet 2* (1991/168 grt).

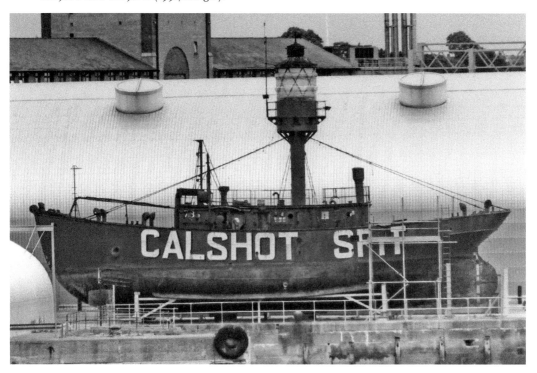

The lightship *Calshot Spit*.

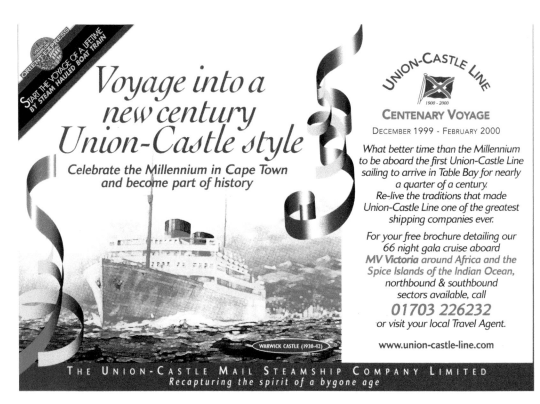

Above: *Victoria* operated a sixty-six-day 'Round Africa' voyage to celebrate the centenary of the formation of the Union Castle Mail Steamship Company in 1899.

Left: HRH the Princess Royal and Miss Zara Phillips named the *Oceana* and *Adonia* at Southampton on 21 May 2003 in Britain's first double cruise ship naming ceremony.

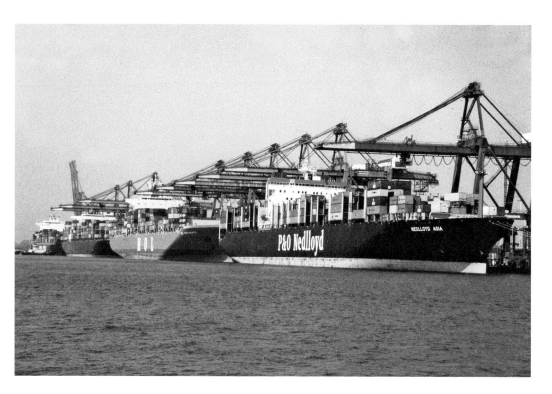

The Southampton Container Terminal.

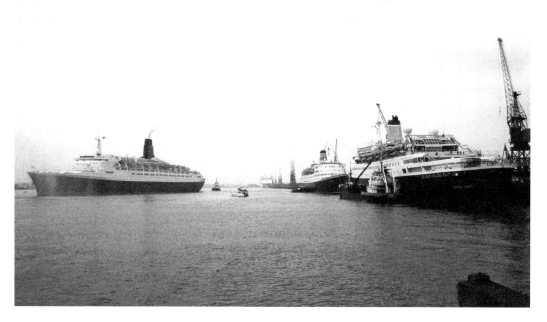

Queen Elizabeth 2 sailing for overhaul in Germany on 23 April 2006. *Saga Ruby* (1973/24,292 grt) and *Saga Rose* (1965/24,528 grt) are also in the port.

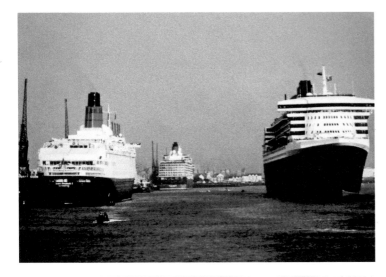

Queen Elizabeth 2,
Queen Elizabeth and
Queen Mary 2.

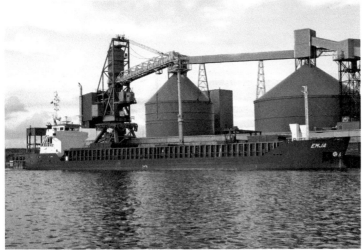

A coastal vessel
discharges at
Southampton Docks.

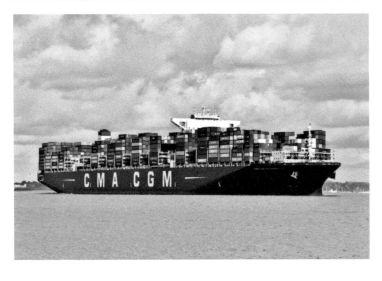

CMA GCM
Bougainville
(2015/175,688 grt).

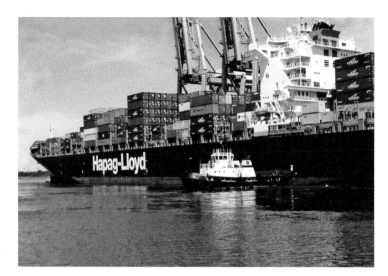

San Francisco Express
(2004/75,590 grt).

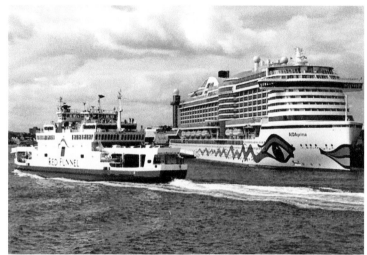

Aidaprima
(2016/125,572 grt) in
the Solent.

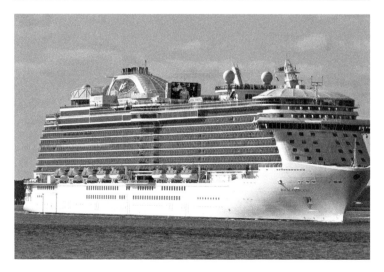

Royal Princess
(2013/142,714 grt).

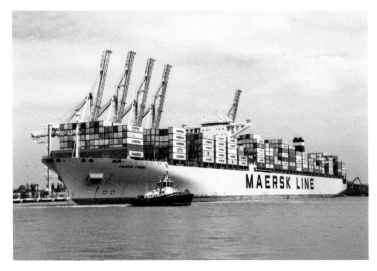

Maersk Line's
Maersk Evora
(2011/141,716 grt)
at Southampton.

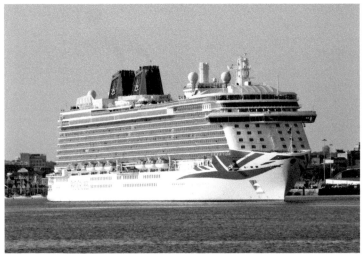

Britannia
(2016/143,730 grt).

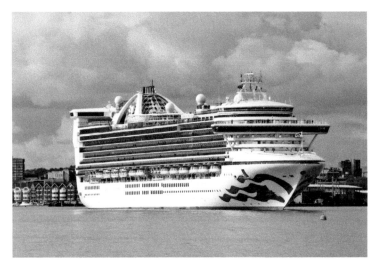

Princess Cruises'
Caribbean Princess
(2004/112,894 grt).